COLOR
HARMONY

ROCKPORT

COLOR
HARMONY
FOR INTERIOR DESIGN

**A GUIDEBOOK FOR CREATING
GREAT COLOR COMBINATIONS
FOR YOUR HOME**

GLOUCESTER MASSACHUSETTS

ROCKPORT PUBLISHERS

Martha Gill

First published in the United States of
America by
Rockport Publishers, Inc.
33 Commercial Street
Gloucester, Massachusetts 01930-5089
Telephone: (978) 282-9590
Facsimile: (978) 283-2742
www.rockpub.com

ISBN 1-56496-620-8

10 9 8 7 6 5 4 3 2 1

Design: Francesco Jost
Cover design: Regina Grenier
Cover Image: ©JAHRESZEITEN-VERLAG/
 G.ZIMMERMANN

Printed in China.

This book is lovingly dedicated to my best friend from childhood, Noreen Chisholm Gardner. Between us (not including dorm rooms or apartments) we have decorated, built, restored, and/or renovated a running tally of more than twenty homes. Most of them hers. At times we have lived in the same city, more often we have been apart, yet distance has never stopped us from sharing our lives. From first loves to parenting to phone calls in the middle of the night, we have shared nearly every aspect of life. As I look through the pages of this book I am reminded of the many pleasant mornings we wandered our separate homes— phones to ears—giving and taking advice, describing in minute detail the placement of objects, tints and shades of paint colors, and bemoaning our sometimes limited budget constraints. Those who know Noreen will attest that her chic sense of design and color is only outdone by her selfless dedication to family and friends, and by her joy for life. Thank you for letting me count you as my dear friend.

I also want to thank Winnie Prentiss, the stylish, savvy publisher of Rockport Publishers, and Managing Editor Jay Donahue for his constant vigil. For her wise counsel, vision, and brilliance thanks to editor Martha Wetherill. Kudos to project manager Jack Savage for keeping me on track and reasonably on-time. For photo researcher Debbie Needleman, who amazingly was able to track down and edit thousands of images based only on descriptions from the "mind" of Martha Gill, to you I owe a debt of thanks.

As always I am grateful to my family who during the process of writing this book often lived with a very anxious person in their midst. Many thanks to my mother, Mary Faricy Pardue, a remarkable woman who taught me how to appreciate the significance of possessions and to never allow them to rule my life. Thank you for continuing to show me that the best way to decorate a home is to fill it with memories, experiences, and people I love. For my amusing, thoughtful and always interesting son, Charlie, I am so proud of you. For my darling, vivacious daughter, Caroline, thank you for sharing your complete love of life with us each day. Lastly thanks to my life-long love, my supportive, loving, exceedingly handsome husband, Doug Sandberg.

Martha Gill

Contents

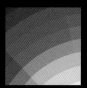

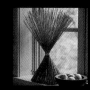
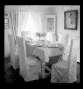

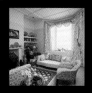

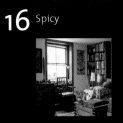

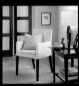

How to Use This Book

USE COLOR AS A VEHICLE TO COMMUNICATE WHAT YOU WANT TO

CONVEY ABOUT YOU, YOUR HOME, YOUR STYLE, AND YOUR LIFE. THINK

OF THIS BOOK AS A WORKING TOOLBOX; IT'S PACKED WITH

DECORATING TIPS, COLOR SWATCHES TO TEAR OUT, PALETTES TO

CONSULT, ADVICE TO CONSIDER, AND COLOR COMBINATIONS TO

INSPIRE YOU. YOU WILL DISCOVER THE BASIC PRINCIPLES OF COLOR

THEORY EXPLAINED IN AN EASY-TO-UNDERSTAND FORMAT, GIVING

YOU THE CONFIDENCE TO MEET DECORATING CHALLENGES WHILE

ENHANCING YOUR OWN INSTINCTIVE COLOR SENSE.

To make it as easy as possible to choose colors and select palettes for your home, *Color Harmony for Interior Design* is divided into twelve color moods. Choose the atmosphere that you'd like to create in your home, then select from the thirty-six color combinations featured within that color mood. In each mood, large swatches of colors reflect classic combinations, as well as the latest trends, such as cool, synthetic ice tints; warm, rich chocolate and mocha coffee hues; deep lemon yellows and tangy citrus oranges; translucent blues; sun-bleached wood tones; and deep indigos.

Decorating tips show you how to choose and use color in your home, including valuable advice on selecting fabrics, paint, furniture, and accessories to create the look you want. Work with the color chips included at the end of the book as you shop for paints, wall coverings, and furnishings.

Explore each chapter and mood to discover your intuitive color sense. Hundreds of modern color combinations for the new century are packed within these pages, ranging from adventurous palettes that motivate to classic design principles freshly paired with color inspiration. For example, learn how a well-planned palette can soften a minimal design, enrich a classic interior, or gently enhance a natural composition. Discover how an organic shape can complement an earthy palette, or how fabric selection can create a mood that generates excitement. Find out how light, texture, fabric, proportion, shape, and scale work together to contribute to the color focus and ambiance of a room.

© Noeru Takizawa / Photonica

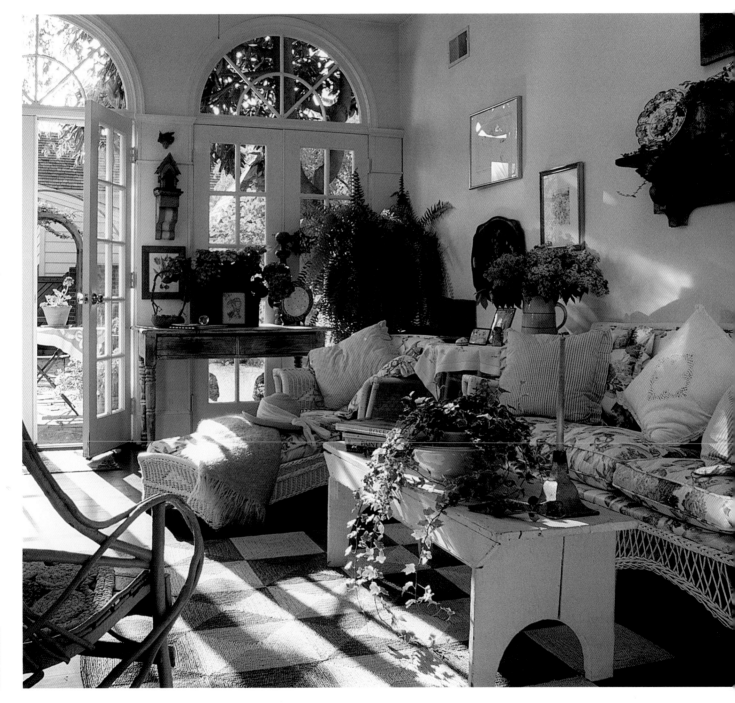

Historical and cultural influences continue to have a dominant presence within the world of decoration and design. Trends include revivals of vintage blends, such as the pastels and autumnal colors of the 1950s; the reinvention of the 1960s' psychedelics; an overhaul of the 1970s' earth tones; and synthetic futuristic hues. Interiors are influenced not only by past decades, but also by lifestyle. Holistic living has created an interest in cool, stress-relieving interiors for the home inspired by health spa environments. Ecological concerns have led to an unprecedented demand for environmentally friendly materials, such as jute, hemp, and canvas. The popularity of second homes has opened up the opportunity for playful design. Lively and amusing decor, once the province of youth, is now sought by the young at heart.

Although color choices have never been so widely available, expansive, or exciting for the professional and home designer, selecting multiple colors to develop palettes need not be daunting or even complicated. Use this book to make sense out of the avalanche of color options and to guide you in selecting colors that express your style. With this book as your guide, you can build beautiful palettes to transform your home with color.

© S. S. Yamamoto / Photonica

Reading the color formulas:

#'s correspond with colors reading from outside to inside

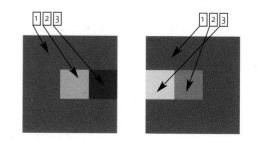

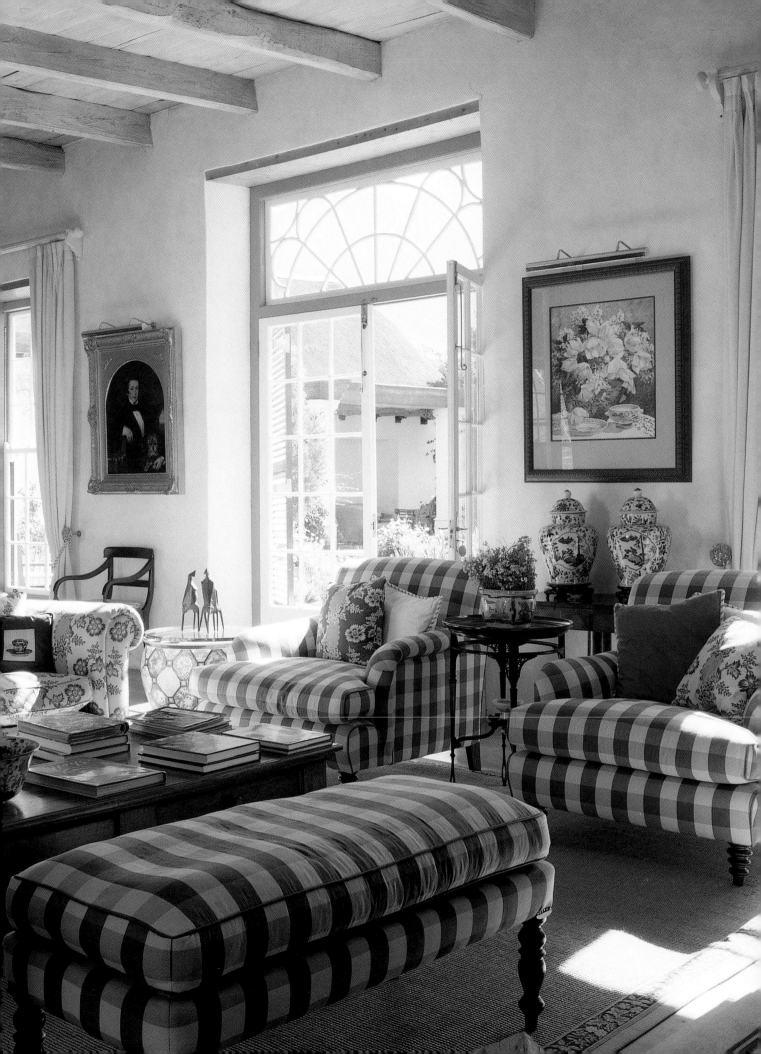

The Color Wheel

The twelve segments of the color wheel
consist of primary, secondary and tertiary
hues and their specific tints and shades.
With red at the top, the color wheel
identifies the three primary hues of red,
yellow, and blue. These three primary
colors form an equilateral triangle
within the circle. The three secondary
hues of orange, violet, and green are
located between each primary hue and
form another triangle.

Red-orange, yellow-orange, yellow-green,
blue-green, blue-violet, and
red-violet are the six tertiary hues.
They result from the combination of a
primary and secondary hue. Constructed
in an orderly progression, the color
wheel enables the user to visualize the
sequence of color balance and harmony.

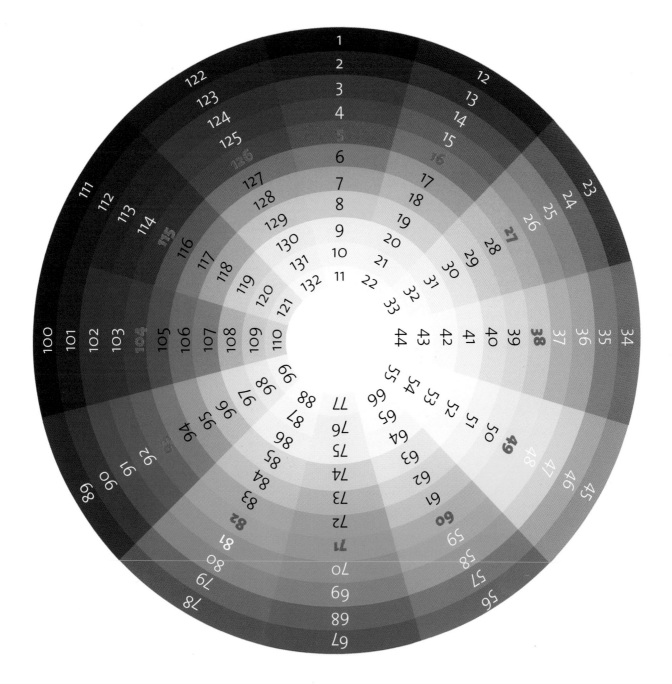

Spicy

Saffron, cinnamon, nutmeg, ginger: use these colors to add a dash of spice to your home decor. Earthen gold, heated red, warm brown, and a dash of bottle green combine to create an aromatic and exotic mix. Red can dominate a spicy color scheme, so decorate with deep shades, such as the rich reds of a Turkish carpet or the orange red of a Pompeiian wall. Take a cue from southern French interiors and use upholstery and table linens with the deep ochre yellow of Provençal fabrics.

The trick to working with such a heady and enticing mix is to add just enough spice to the blend. Decorate with neighboring colors from the warm side of the color wheel; begin with toasty, full-bodied reds and move toward piquant oranges paired with tangy mustard yellows. Mix warm, organic woods that are rough-hewn and chunky with hand-woven fabrics, such as kilim and dhurrie rugs, or paisley throws.

To prevent ruddy red and rich orange from overwhelming a spicy scheme, consider including chocolate brown and amber hues to create a mood that's both comfortable and lively. Combine raw earth hues with judicious amounts of the cool colors associated with the Eastern spice trade—cooling aquamarine, vivid lime, or glassy emerald green—to add contrast to a warm and spicy decorating scheme.

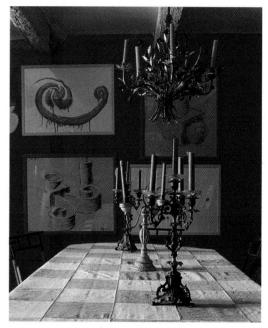

© Jacques Dirand / The Interior Archive [Designer: Michel Klein]

[ABOVE]
To temper a red-hot wall color, decorate with cooling shades of green, such as this blue-green and white checkerboard patterned tablecloth.

[RIGHT]
It is not only the ochre yellow wall color that heat up this living room; Rugs and throws from India and the Middle East, infused with exotic mixes of full-bodied red, yellow, blue, and green, add spice and comfort to a sunny corner. Use oriental, Navajo, or dhurrie rugs on floors to define conversation, group furniture, or add warmth to any room.

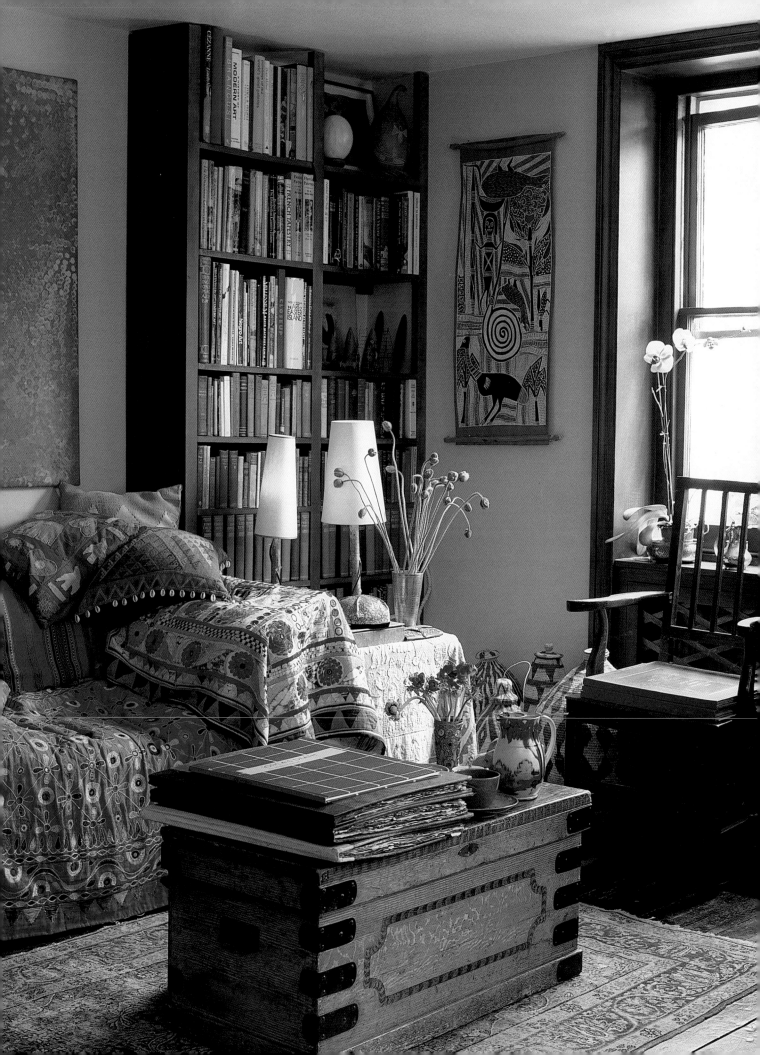

2
3
4

15
14
13

27
26
25

125
124
123

5
3
1

38
37
36

5
71

1
73

2
67

6
68

1
74

3
75

114
125
4

4
15
26

122
1
12

6
17
28

116
127
6

123
2
13

■ 5
■ 57

■ 4
■ 79

■ 1
■ 56

■ 2
■ 78

■ 13
■ 60

■ 15
■ 86

1
142

2
147

3
152

4
144

5
141

6
140

1
133

2
135

3
137

4
143

5
145

6
148

Decorating with a spicy mix

A spicy decorating scheme is inclusive, warm, and eclectic. Its heady mix of earth colors complements and enhances a collection of international fabrics and accessories. Its warm tones heat up large, impersonal, or cold rooms. And its range of colors, from chili red to sari pink, with references to the Eastern spice trades of the eighteenth and nineteenth centuries, works well with an eclectic blend of contemporary furniture, family heirlooms, or prized antiques.

A kilim rug is the perfect floor covering for a spicy room; its earthy hues of red, yellow, and brown will work with several hot color schemes. Introduce small touches of a cooling green, such as green landscapes or accent pillows, to keep spicy colors from overheating.

© Tim Clinch / The Interior Archive [Nacho James]

Spicy **Tips**

•Vibrant and passionate, spicy hues look their best when used against a neutral backdrop, such as linen, jute, woven grass wall covering, canvas or linen upholstery. Conversely, to render a large, cold space warm and inviting, paint walls with spice tones to create a cozy sense of enclosure.

•Spicy hues enhance contemporary rooms as well as traditional ones. Stainless steel, glass surfaces, and shiny synthetic fabrics bring a modern glow and give spicy earth tones definition and gloss. Kilim pillows provide an authentic accent and add instant warmth to any room or nook. Although pillows in the kilim style are widely available at retailers, look for cushions or pillows covered with genuine patterns and dyes at purveyors of authentic kilim rugs.

•Spice tones blend well with organic shapes, well-worn books, and objects collected on travels. Coordinate these seasoned colors with your most cherished collections, small drawings or prints, natural materials, and fibers.

•To keep a spicy color combination from overheating, add small doses of cooling colors like turquoise and emerald green to the mix. Or lighten a wide expanse within the room with a neutral hue; for example, weathered limestone flooring provides a cooling base for a heated interior.

•Place small decorative accents on side tables, window sills, and ledges to complete the mood: Arrange cardamom pods, star anise, and the common cinnamon stick in shallow pottery bowls to introduce the welcoming aromas of exotic spice.

•Natural fibers and fabrics woven without dyes or artificial colorings provide a textured backdrop to enhance a spicy color scheme. Select from plain woven cotton; rough linen; jute and a growing array of woven grasses and palm fibers; or sturdy, unbleached canvas.

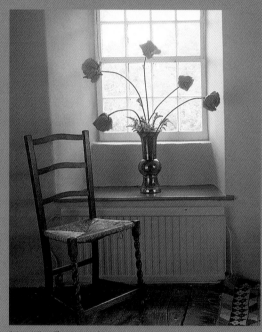

©Henry Wilson/The Interior Archive

[ABOVE]
A spicy scheme can enliven the Colonial charm of an antique setting. As pretty as it is practical, the sturdy weave and glowing color of a kilim rug brings a bit of richness to the simplicity of the room.

[RIGHT]
A collection of antiques reminiscent of the Spice Trade—a celadon platter, Chinese sideboard, and brass candlesticks—add texture and history to the spicy background of a gold-stenciled, orange wall.

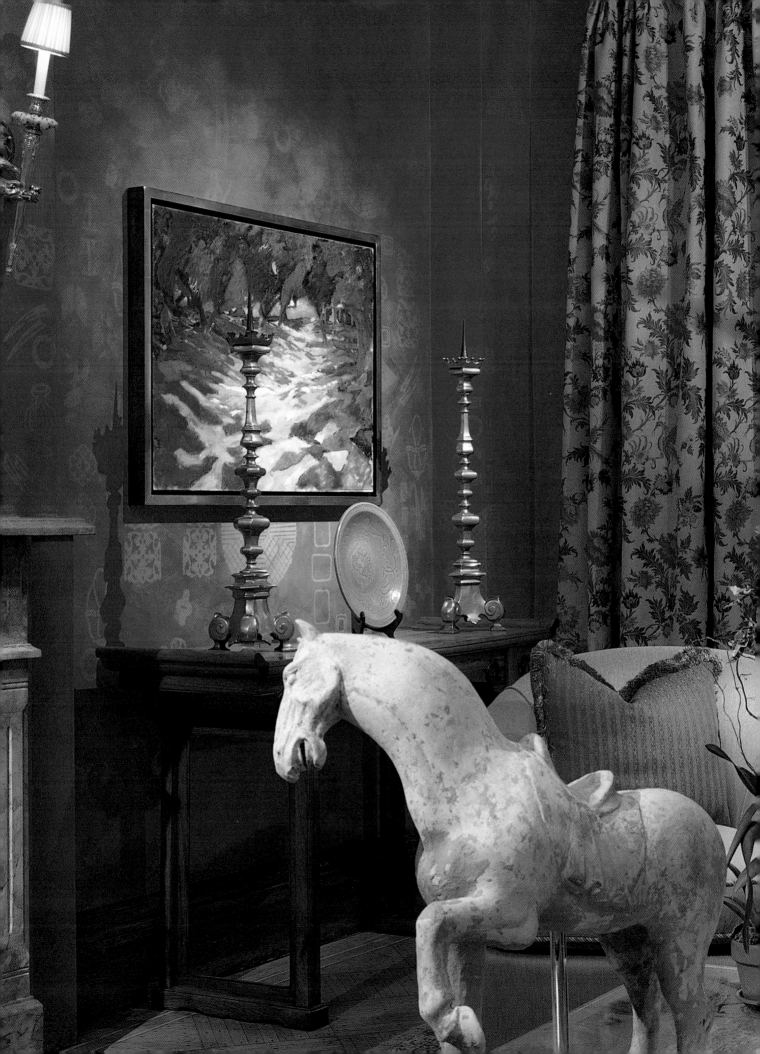

Exotic

Merge East and West for exotic decor that's perfect for dreaming grand dreams. Exotic and sensuous cinnabar—red with a hint of orange—is favored by the East. Feng shui experts consider this warm hue the color of recognition and fame. Distinctive and inviting, this ruddy red is a natural partner for brightly spiced oranges and muted earth tones. Shiny metallics, gold, and copper heighten and evoke the mystic properties of exotic cinnabar hues. Paired with whites and creams, this stimulating palette shimmers, while small amounts of soothing aquamarine cool this provocative blend. A lucky color, this enriched red is simultaneously minimal and grand, restrained and opulent—a hue of mystery and delight.

Exotic interiors span the globe and offer inspiration—from small Tibetan shrines to antiquities from China to intricate carvings from Japan. Recreate the look of a faraway place by blending select imports with contemporary low-level seating, floor cushions, and accessories with a nod to the Orient. Balance an exotic mix with a variety of woods, from dark rich hues to rosewood, bamboo, or teak. Continue the rich tradition of exchange between East and West by combining furnishing styles, art, and accessories. Counterbalance the grandeur of lacquer, gilt, brightly colored fabrics, and statuary with plain wood floors, tatami mats, and streamlined modern furnishings that hug the ground.

© Keiji Watanabe / Photonica

[ABOVE]
Lanterns, kites, fans, or parasols generally constructed of paper are all inexpensive accents that add mystique to an exotic interior. For example place an open parasol in a strategic location for a flash of color, or simply group several that are shut and place in an antique umbrella stand.

[RIGHT]
Statuary and carvings from deities to temple tops add a mesmerizing aura to an exotic decor.

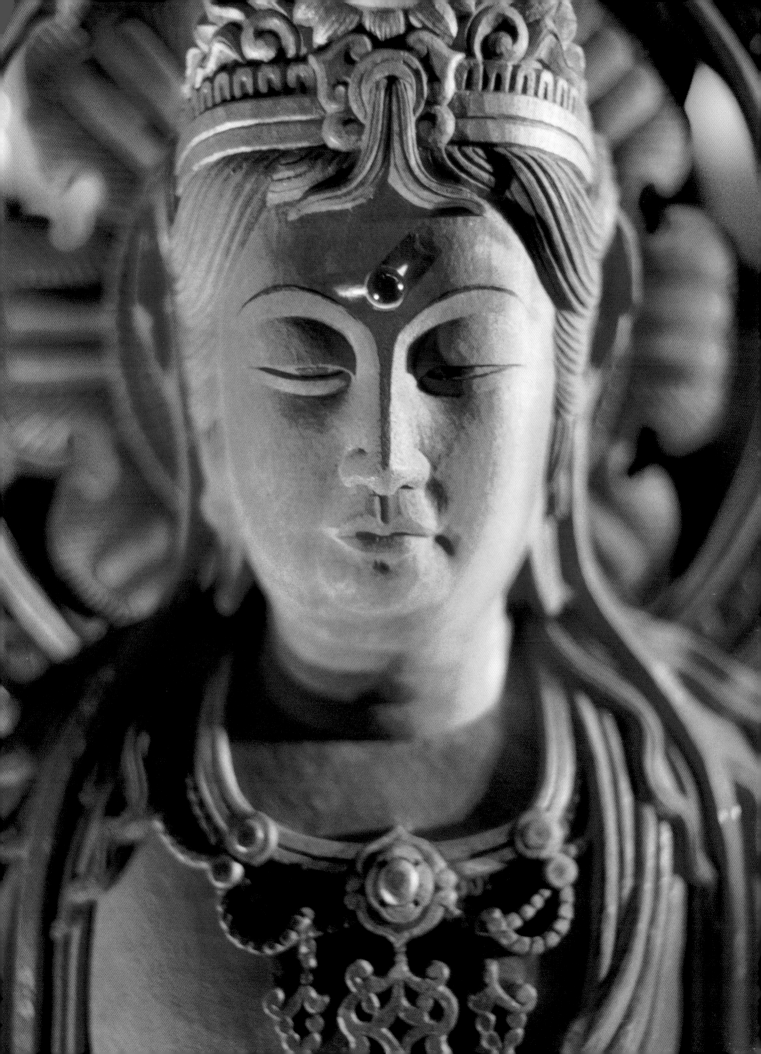

16
14
12

13
17
16

14
16
12

12
16
18

18
14
12

17
16
13

16
18

12
81

17
78

15
78

12
83

18
78

16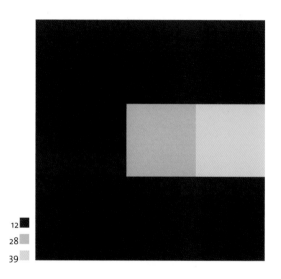
27
38

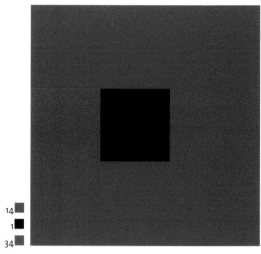

14
1
34

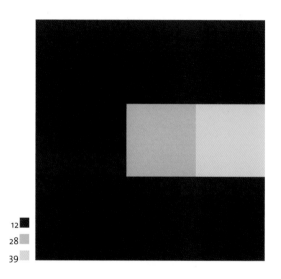

12
28
39

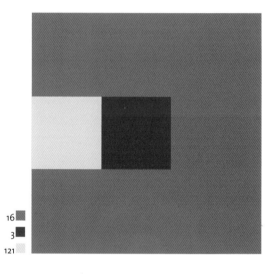

16
3
121

17
3
26

18
40
29

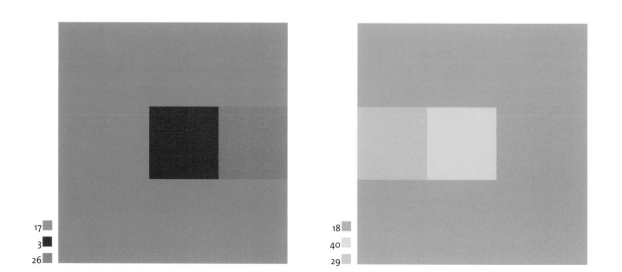

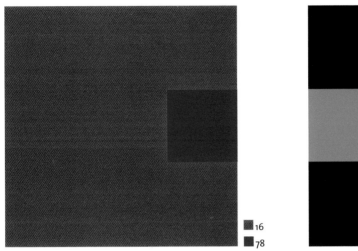

■ 16
■ 78

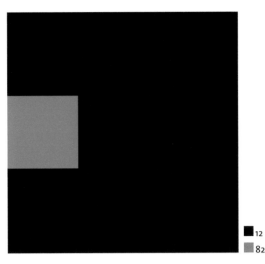

■ 12
■ 82

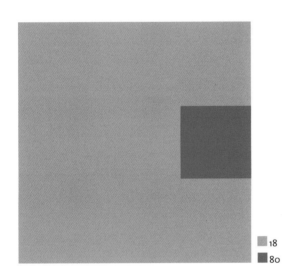

■ 18
■ 80

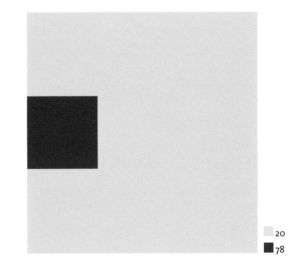

■ 20
■ 78

■ 17
■ 83

■ 14
■ 80

16
148

14
149

17
152

15
148

13
151

12
142

16
142

14
147

18
149

16
134

15
145

16
140

Decorating with
an exotic mix

Foreign and familiar, an exotic decorating scheme is expressive and intriguing—creating a place for your spirit to soar, dreams to unfold, wishes to materialize. While an exotic decor requires thought and planning to cultivate, the provocative stimulation of this unusual decor is the well-earned reward. The soul of an exotic interior is the imaginative mood that overtakes you when you enter.

This exotic and eclectic mix of furnishings and accents is reminiscent of treasures collected along the old routes of the Spice Trade. Deep mahogany and burnt orange create a pleasant atmosphere, great for sparking the adventurous imagination.

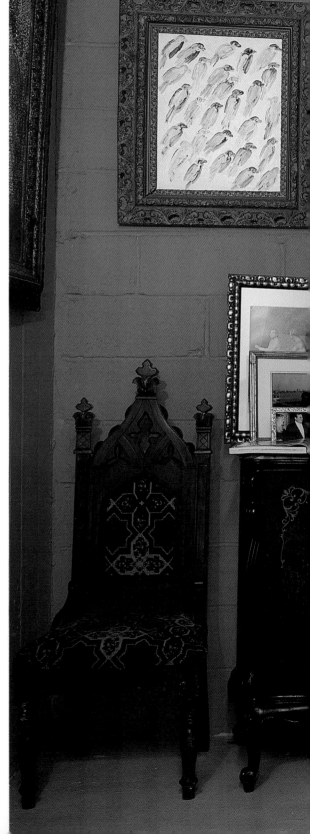

Antoine Bootz

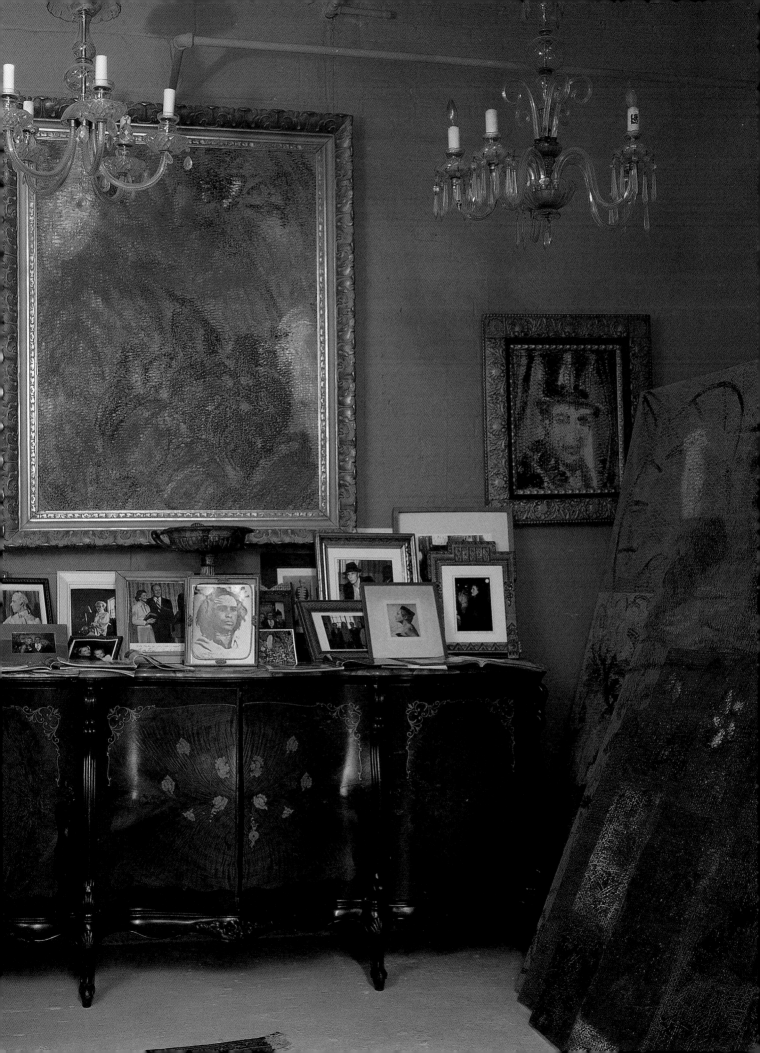

Exotic **Tips**

•Use fragrance to enhance color within an exotic decor. Cinnamon and mandarin orange scents relate to fire-the element associated with a red-orange cinnabar hue. Choose from incense sticks, vaporizing oils, perfumed stones, and candles.

•Within an exotic interior, hanging fabric panels and curtains can act as room dividers, bringing large expanses of color to an environment. Also consider more neutral as well as traditional screens of translucent paper, bamboo, or carved wood.

•Particularly when planning an exotic interior with an Eastern influence, consider consulting a feng shui expert or book for guidance. The philosophy of feng shui is to live in harmony with your environment so that the energy surrounding you works for you rather than against you. Attention to the placement of objects and furnishings when decorating is one of feng shui's basic principles. It is suggested that you combine equal amounts of light and dark furnishings, along with light and dark colors, to bring positive energy and balance to a room.

•Moderate-to low-priced imports, such as paper lanterns; fabrics that feature small mirrors and embroidery; carved figures; and candle holders, are widely available. Go global by carefully selecting several pieces to blend with more expensive and substantial finds, such as a painstakingly crafted piece of Japanese cabinetry. Classic choices from the East include staircase chests (tansu), display cabinets, calligraphy boxes, and wheeled chests.

•Combine sleek decorative lacquerware and opulent accessories with simple furnishings for a yin/yang balance. Seek out blue-green (the complement of red-orange) when selecting visual accents to bring to a room.

•Recycle a couch by covering with a shimmering satin sheet. Don't sew or cut the fabric unless you absolutely must-just bunch and tuck. The loose fit is part of the look and makes your impromptu slipcover easy to launder.

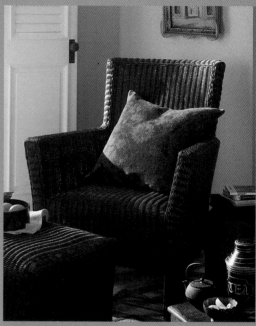

© Crate & Barrel

[ABOVE]
Merge East and West furnishing styles. Muted, dark stained wicker with a matte lacquer finish is a natural partner for this Asian-inspired Ottoman-style table that rises only inches above the floor.

[RIGHT]
Infused with the exoticism and mystery of the East, this mix of subdued colors and the unadorned wood of the floor and furnishings brings harmonious atmosphere to a quiet retreat.

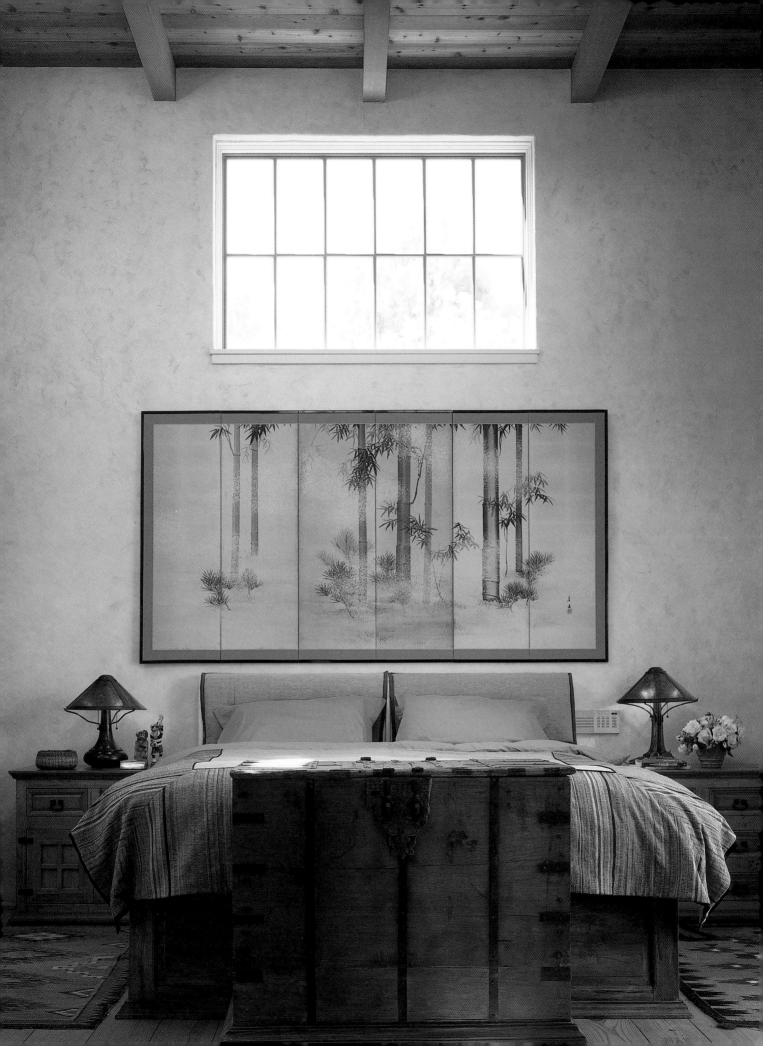

Dynamic

Orange is sporty, active, and dynamic—a favorite of mid-century modernists. When using this energetic color, be wary of overpowering even the most wide open living space. However, selective splashes of dramatic orange will brighten, and enliven small and large interiors. Team orange with red-orange and yellow-orange for an analogous combination or with shocking pinks for a feminine mix that sizzles. Saturated lime green is another welcome addition to a powerful palette that focuses on orange. If your choices feel overheated, judicious amounts of complementary blues or lots of natural cream and white will cool this palette.

Sculptural furnishings of plastic, metal, molded wood, tubular metal, and glass work well within a kinetic design that features a stimulating palette. Retro fabrics and furniture styles add to the dynamic. Look for new interpretations of vintage furnishings that use biomorphic curves, such as a boomerang or kidney-shaped coffee table. Fabrics that feature 1950s space-age icons such as amoebas and atomic kitsch bring energy and humor to a lively interior. Modernize with a lively tangerine sectional and pillows in new earth tones.

Multipurpose, multi-task living is a dynamic component of modern life. Expansive rooms— where the majority of home living takes place— continue to grow in popularity. Open-air life requires special attention to furniture placement, storage solutions, and room divisions. Select basic, clean-lined storage components that can be reconfigured as your needs change. Group furnishings away from the walls to create cozy centers, and use movable screens or sliding doors to create divisions within a spacious interior or to enlarge a small room.

© IKEA

[ABOVE]
A coat of tangerine orange paint paired with inexpensive natural wood shelving is one way to create a flexible storage area that's also dynamic. Another is to paint the interior of a cabinet that has transparent glass doors a sassy hue to add interest and surprise.

[RIGHT]
A dynamic scheme can be founded on a few bright accents without requiring an all-over wash of color. Here, freewheeling slices of bright, saturated hues give bold energy to an open space.

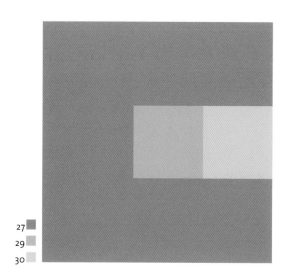

27
29
30

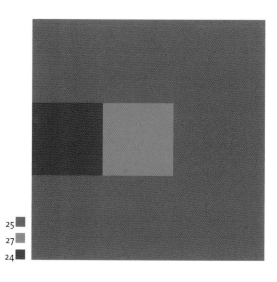

25
27
24

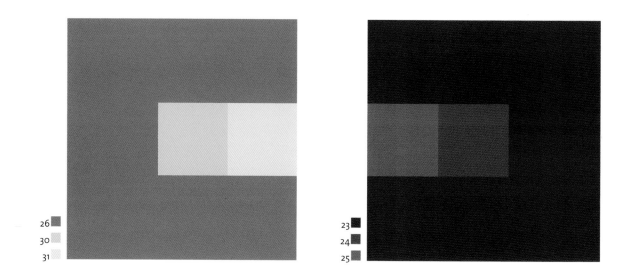

26
30
31

23
24
25

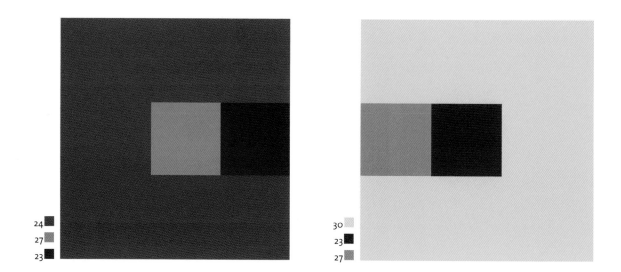

24
27
23

30
23
27

27
89

27
93

24
89

25
95

29
89

31
90

27
36
46

24
37
47

23
34
45

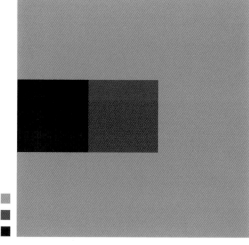

27
14
1

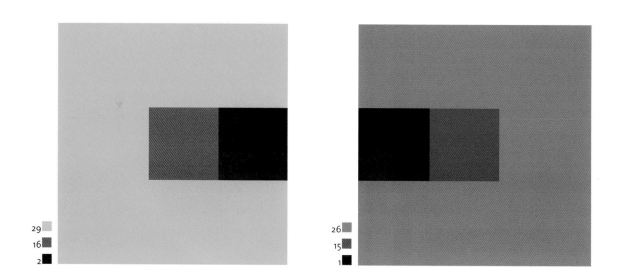

29
16
2

26
15
1

27
85

28
78

23
84

25
110

27
100

23
102

27
133

28
149

30
152

25
152

23
142

27
142

28
151

27
141

27
149

25
148

23
142

23
152

Decorating with
a dynamic mix

A dynamic color palette is sassy and bright. Its

exuberant blend of spirited colors brings

both large and small areas to life.

Retro accessories, vintage fabrics, and freshly

interpreted furnishings set the stage for the

drama of life. Be bold: dare to mix poppy orange,

cinnabar reds, and lively 1970s hues with a

neutral background or complementary hues for

explosive design.

Efficient storage solutions offer a dynamic option for creating
a bedroom that also functions as a personal center for well-
being. White bedding, natural woods, and rattan wall-to-wall
flooring recede to allow the simplicity of two orange pillows
to dominate this multi-tasking room.

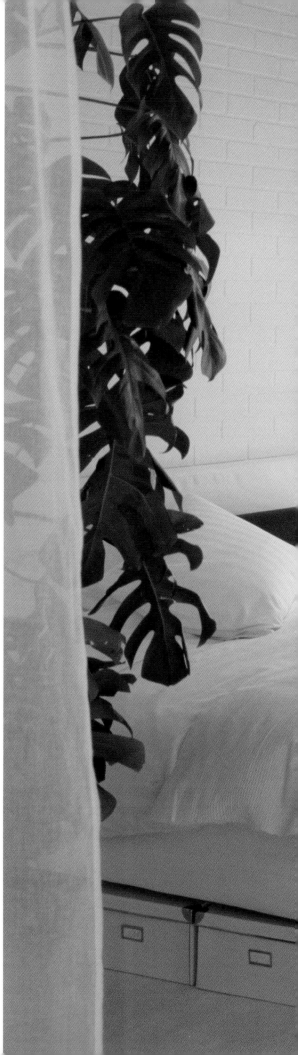

© IKEA

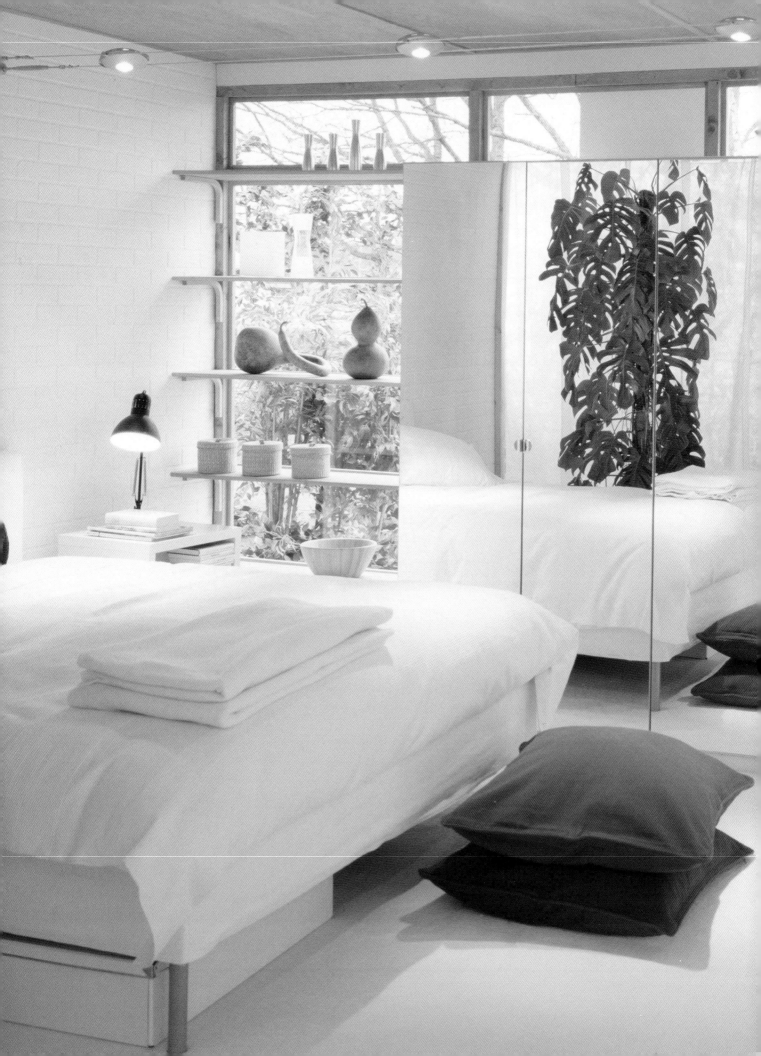

Dynamic **Tips**

•Pulling furnishings away from the wall will make a large or small room appear larger. Use a bright orange area rug to create a dynamic conversational grouping. Whether your room is large or small, try floating your couch or sofa away from the wall.

•Get more function out of your couch by placing a console or sofa table behind it to store and stack books or hold a reading lamp.

•Use focused light to create drama and spotlight dashes of vivid color in your interior. Consider pole lamps, hanging ball lamps covered with translucent rice paper, or halogen lighting. Use spots and dimmers to strategically light colorful furnishings, accents, walls, and artwork. Place inexpensive can lights on the floor behind furnishings or indoor plantings for dynamic uplighting.

•Transform a large or small space into a high-performance environment tailored to your life. First determine your day-to-day, short-and long-term needs, then use modular shelving and organizers to keep everyday items readily available. Short-term items can be stored in rattan baskets or galvanized metal bins, while industrial utility shelves on wheels, rolling carts, and bins provide flexible long-term storage and can easily be pushed out of sight.

•Hunt for colorful accessories that recall the mid-twentieth century, such as biomorphic vases, iconic supergraphics (think big dots, psychedelics, and arrows), atomic wall clocks, and "Jetson" style appliances. Well-placed dashes of vibrant color add energy and vigor to a dynamic decor.

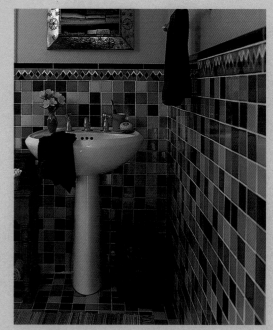

©Phillip Ennis Photography

[ABOVE]
Transform a small space, such as this bath, with a dynamic mix of blue and green tiles beneath orange walls.

[RIGHT]
Use complementary colors such as these vivid blue pillows and lamp shades to add interest and energy to a dynamic decor.

Natural

Decorating with natural materials creates a haven for modern living that is soothing to the soul. Today we desire serenity and peace within ourselves and our environments.

Restful environments often use gentle palettes that seek their inspiration from the land. Colors that draw their inspiration from the earth, such as warm ruddy browns, golden mineral hues, or pale eggshell and bone tints, create an atmosphere of calm.

Use the earth tones of materials such as unbleached linen and fabrics colored with natural dyes when composing your own living environment. Discover the infinite variety of yellow-orange paints and the moods they create. Light tints of yellow-orange will enlarge and brighten a small room or entry, creating a welcoming sense of space. Deeper honeyed shades bring warmth to a great room with high ceilings and humanize large open spaces. Select a dense caramel paint to create a cozy meditative environment. For a natural look, seek furnishings that are designed in the unadorned Shaker style, garden-influenced pieces costructed from wicker, cane, and bamboo, or simple hand-carved furniture.

A naturally based interior is the undisputed workhorse of interior decorating. Creamy walls paired with wooden floors are to an interior decorator what canvas is to an artist. The simplicity of plain pine floors and buff walls is the perfect base to build upon. Impact colors such as Chianti red and amber orange can be introduced in the form of changeable soft furnishings like pillow coverings and slipcovers. Seasonal accessories can also add interest to a natural decor—for summer, imagine oversized candles placed in trays surrounded by a mound of recently found seashells, or for autumn a sheath of cane or wheat bound at the base with raffia to fill an urn or vase.

© Crate & Barrel

[ABOVE]
Floor coverings for all-natural fibers such as jute and coir can be found in a wide variety of shapes and colors. If asked, many home outlets will cut and bind these inexpensive rugs to your specifications.

[RIGHT]
Balance and Simplicity. Use a bundle or two of natural cane reeds as a seasonal touch in the late summer and early autumn months.

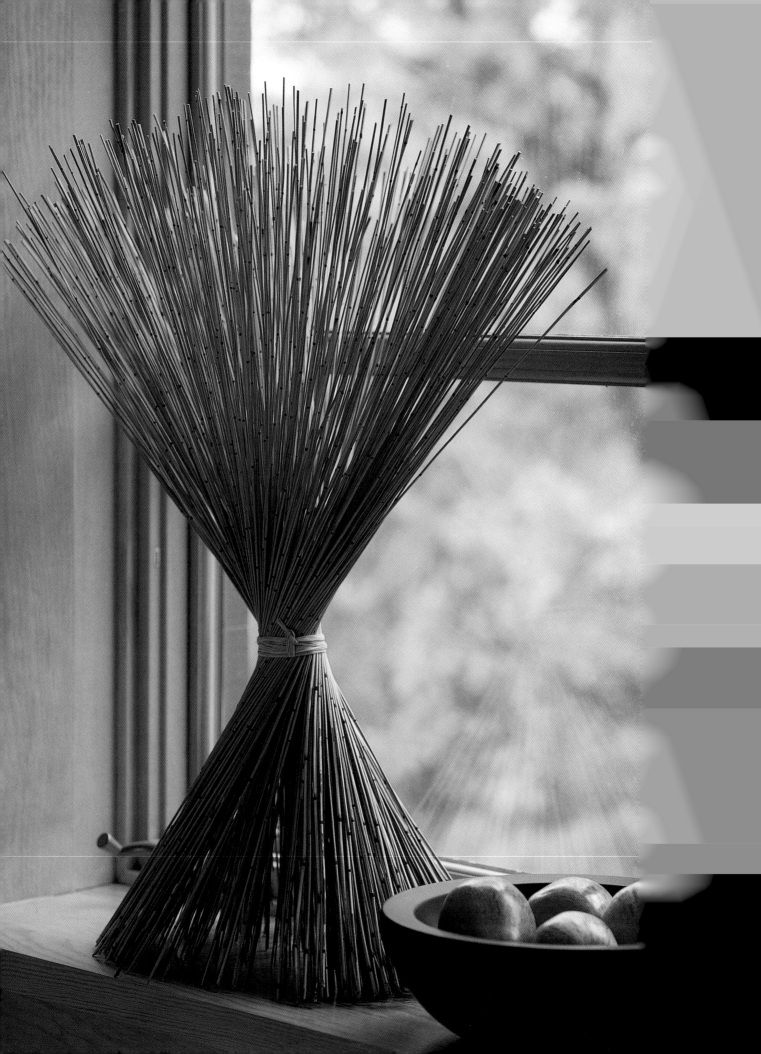

37
38
39

41
40
39

43
41
40

35
37
36

38
41
44

34
41
42

38
100

40
110

36
109

44
101

41
107

35
106

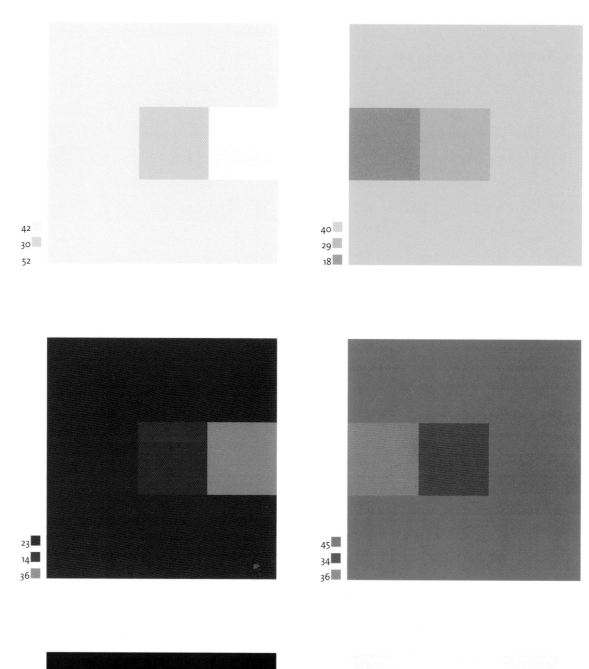

42

30

52

40

29

18

23

14

36

45

34

36

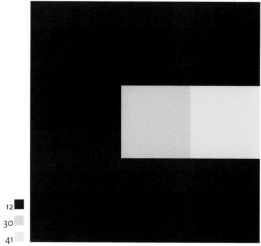

12

30

41

44

20

30

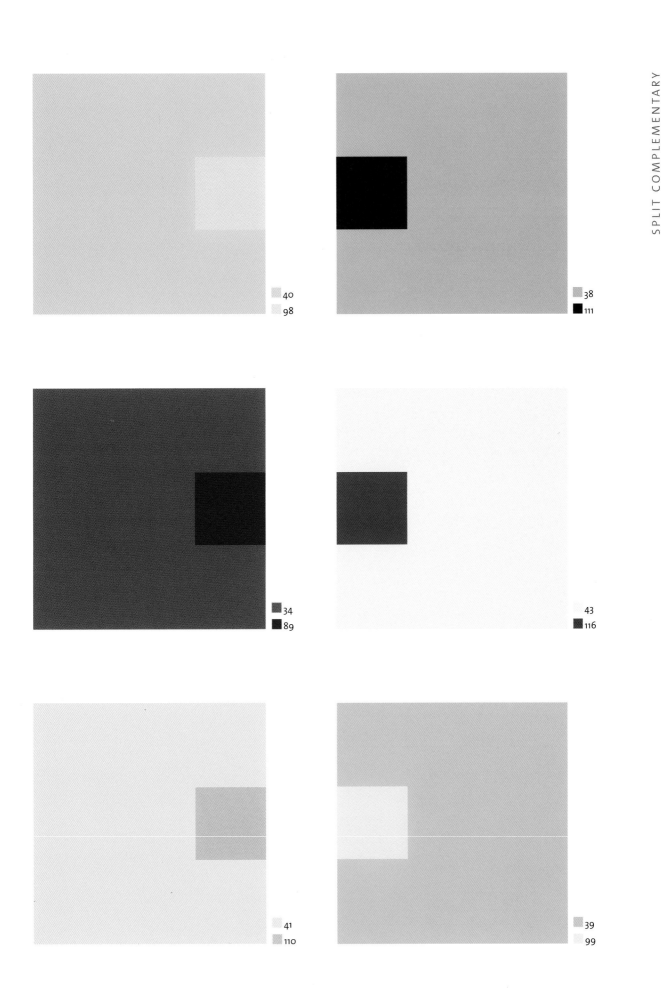

40
98

38
111

34
89

43
116

41
110

39
99

40
149

42
150

36
152

34
151

41
141

40
142

39
133

35
150

41
148

44
149

34
139

38
142

Decorating with a natural mix

Welcoming and calming, a golden-hued palette also emphasizes texture. Delicately handwoven fabrics, natural fiber floor coverings, and crisp buttery cottons will all add interest to a simply inspired decor. The smooth quality of burnished coppers, ambers, and golds work to ground an earth-based scheme. Watery blues and sky-inspired violets combined with natural sunlight bring life and energy to a natural color scheme. Balance these basic colors of the earth with texture, shape, and seasonal accessories for an atmosphere that reflects your personal taste.

Faux beams of rustic wood are used to give this enclosed dining room an outdoor, natural mood. The monochromatic table and chairs provide a stage for dramatic dining.

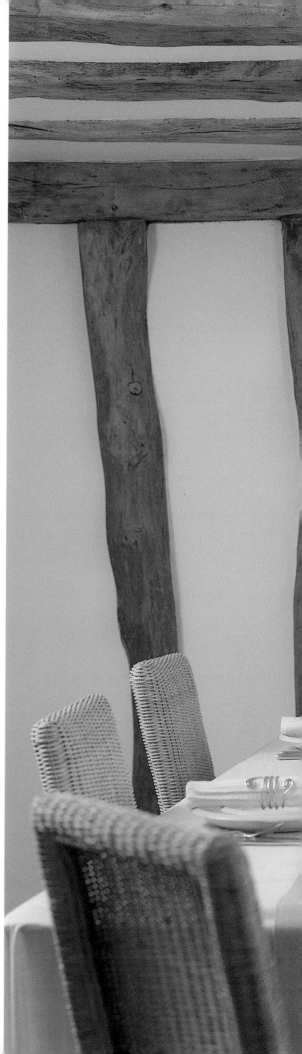

Natural **Tips**

•Warm a room with the rich colors of glowing embers by grouping furniture around a fireplace. This creates an instant oasis of calm, particularly in a busy open room. Generous low seating, oversized coffee tables, a variety of cozy throws, and softly glowing embers from the fire will enhance the feeling of well-being that a natural interior bestows.

•Use paint to create an accent wall. Paint one wall a rich butter cream hue. Consider painting adjoining rooms with analogous colors, such as saffron yellow or nutmeg orange. Contemplate painting moldings, window and door trim a darker contrasting shade instead of the standard white. A saturated, glossy olive green or shiny chocolate brown will create depth and interest when paired with soft honey or cream hued walls.

•Select your furnishings for a natural room carefully—every item need not be a "star." First determine what pieces will be background and which pieces will be featured. For example, an unattractive dining table can be covered with a plain unbleached cotton cloth and a natural linen table runner, allowing the focal point to become a set of woven wicker chairs.

•Everyday tea can be used to dye fabrics naturally. Experiment with rose hip, hibiscus, and chamomile to achieve a variety of shades. Ruddy natural hues can be achieved with rose hips tea while more yellow to gold tones result from hibiscus and chamomile. Dampen the fabric completely (cotton blends work best) and submerge in a tea bath until the desired tint is achieved.

•Inexpensive canvas Roman shades or bamboo blinds may be all you need for window treatments in a room that features a natural palette. Alternatively, consider leaving windows bare, as natural interiors embrace light.

•Create form and function within a natural room by using wicker baskets of assorted sizes to store toys, magazines, and the clutter of everyday life. Baskets can be hung, stacked, or nested when not in use.

© Fritz von der Schulenburg / The Interior Archive [Designer: Nico Rensch]

[ABOVE]
Clean and honest, the inter—related decorating styles of Shaker, mission, and arts and crafts lend themselves to the unpretentious colors of the earth. On this bed, standard sized pillows in plain cotton covers are arranged vertically to bring height to the overall look of this simple bedding.

[RIGHT]
A rich layering of textures and colors taken straight from forest and earth—glowing natural hues of sunset orange warm the rough stone of a wash basin and its base of smooth wooden planks.

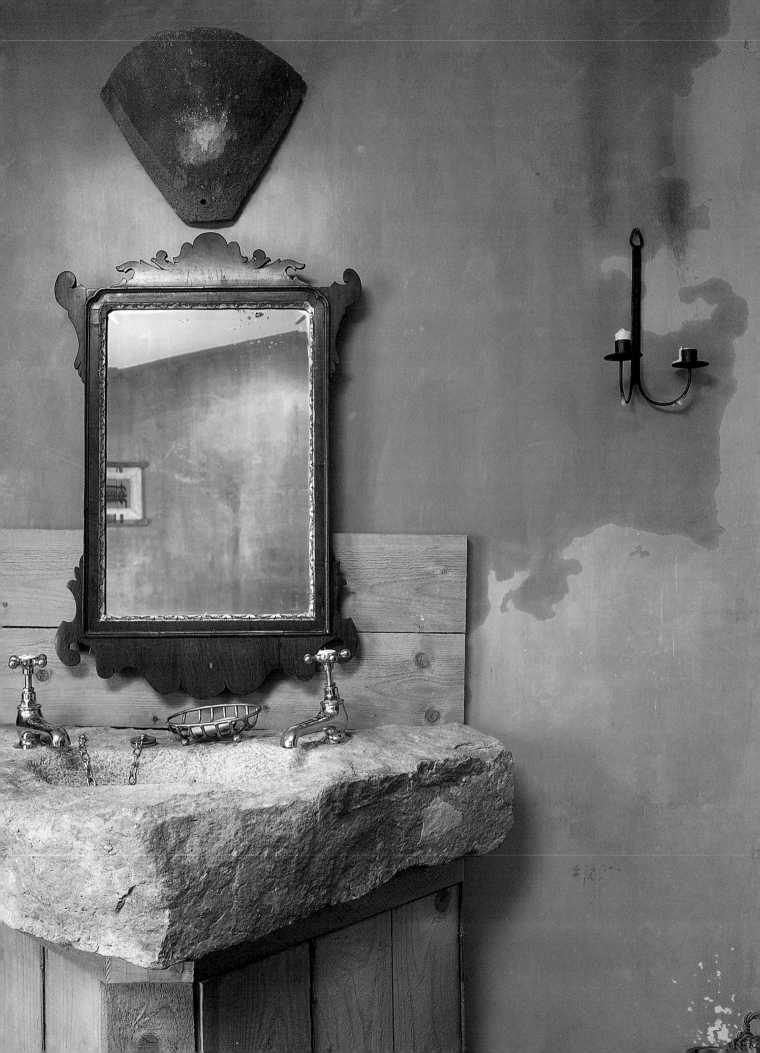

Luminescent

A luminescent interior shines with hospitality and warmth. When you decorate with the luster of yellow, you illuminate your home. The brightest hue of the color wheel, yellow beams, growing more radiant with the addition of white. An assortment of creams, from ecru and oyster to rich shades of caramel and honey, enhance yellow's appreciation of natural light. Blend warm, glowing yellows with yellow-orange and orange for a glowing, analogous color scheme. Pair with light dove gray for the semblance of candlelight on a cold winter day. Strong, robust yellows combine well with jewel toned greens and indigo blues. When mixed with yellow, warm browns inspire a retro 1970s' mood.

Look to the French, masters of style and light, for inspiration when decorating an interior centered around yellow. Traditional furnishings like simple country French, or even a slightly more formal mood, suit the disposition of a yellow-focused room. To accent a luminous decor, select gilt mirrors and picture frames; accent tables of rich wood or shimmering metal and sculpted wire; translucent window treatments and tapestries. Create an ever-changing mood with reflective glass, mirrors, and metals, which all combine well with yellow to achieve an uplifting luminescent scheme. Wallpaper that mimics fabrics, such as jacquard or damask, and seasonal velvety slipcovers bring luxury to a luminous decor. Decorate with yellow to further illuminate rooms with large windows that capture the early morning sun. As the day progresses, light candles and flickering votives to add the friendly glow of candlelight. Choose lamps for low-level lighting and replace tired light fixtures with vintage reproductions that feature frosted shades and milk glass to maintain a welcoming glow into the night.

© Charles Maraia / Photonica

[ABOVE]
Light candles to bring a luminescent glow to any interior.

[RIGHT]
Position furnishings so that they are bathed in the light of day like this country French table that features tone on tone linens in tints of radiant yellow. Use blinds, drapes, or slipcovers and tablecloths to protect from damaging rays.

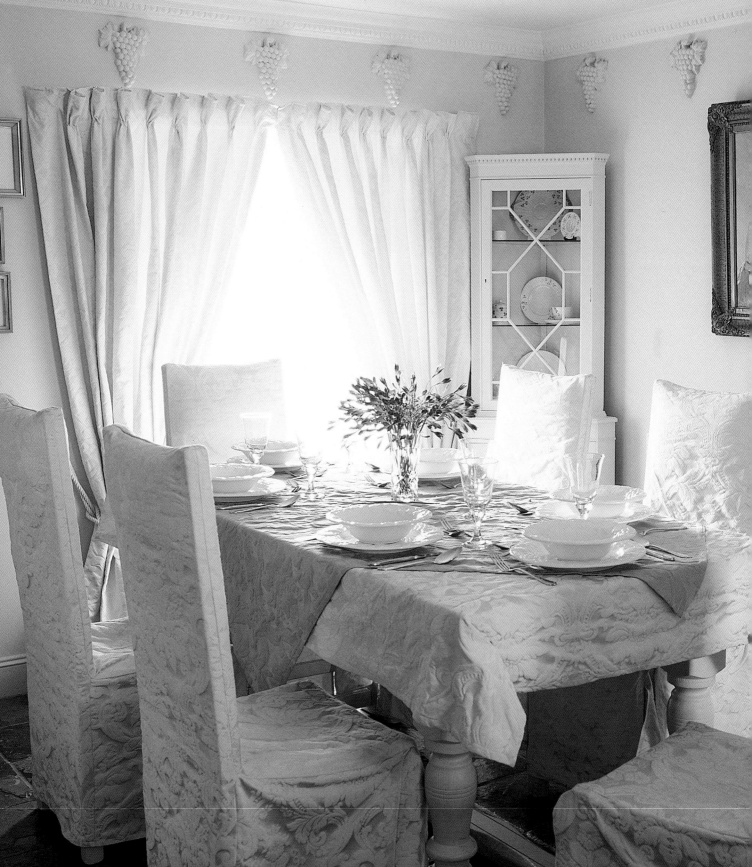

48

51

52

50

45

47

46

48

45

51

53

55

52

47

45

55

52

51

50
111

48
112

52
121

45
111

47
121

115
54

52
39
28

48
34
25

45
36
37

52
63
75

54
64
75

45
62
74

45
122

52
123

47
130

45
100

54
100

52
102

51
133

54
132

53
149

52
148

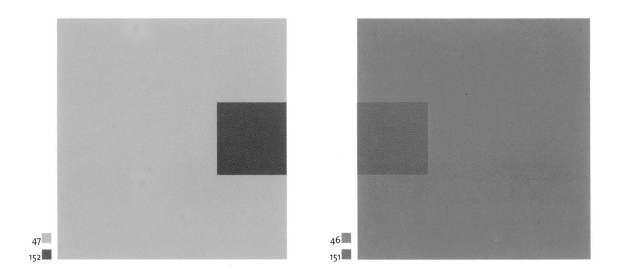

47
152

46
151

45
149

48
142

47
152

51
142

52
142

52
152

Decorating with a luminescent mix

A luminescent decor captures and reflects the essence of light. From the sun-splashed rays of natural daylight to a thoughtfully placed lamp, the aura of a light-filled room is pleasingly hospitable and filled with the glow of life. Decorate with yellow and its various tints and shades for a home that is always gracious and warm.

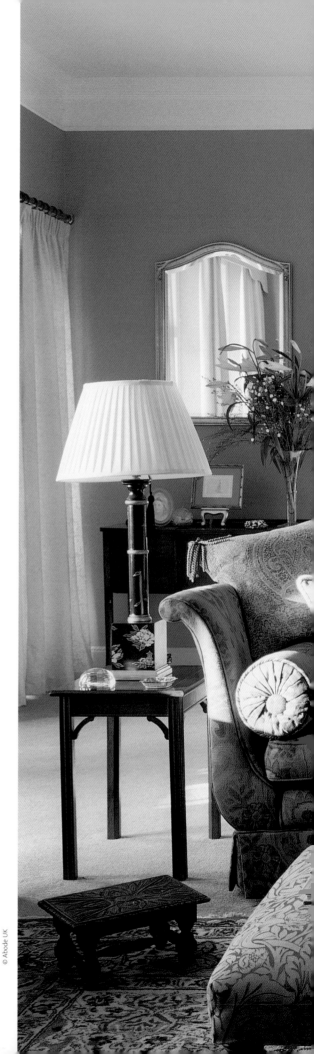

The play of natural daylight is the focal point of this symmetrically balanced traditional decor. Butter tinted creams and yellowy sage pair with rich woods and black accents for a welcoming yet formal room.

© Abode UK

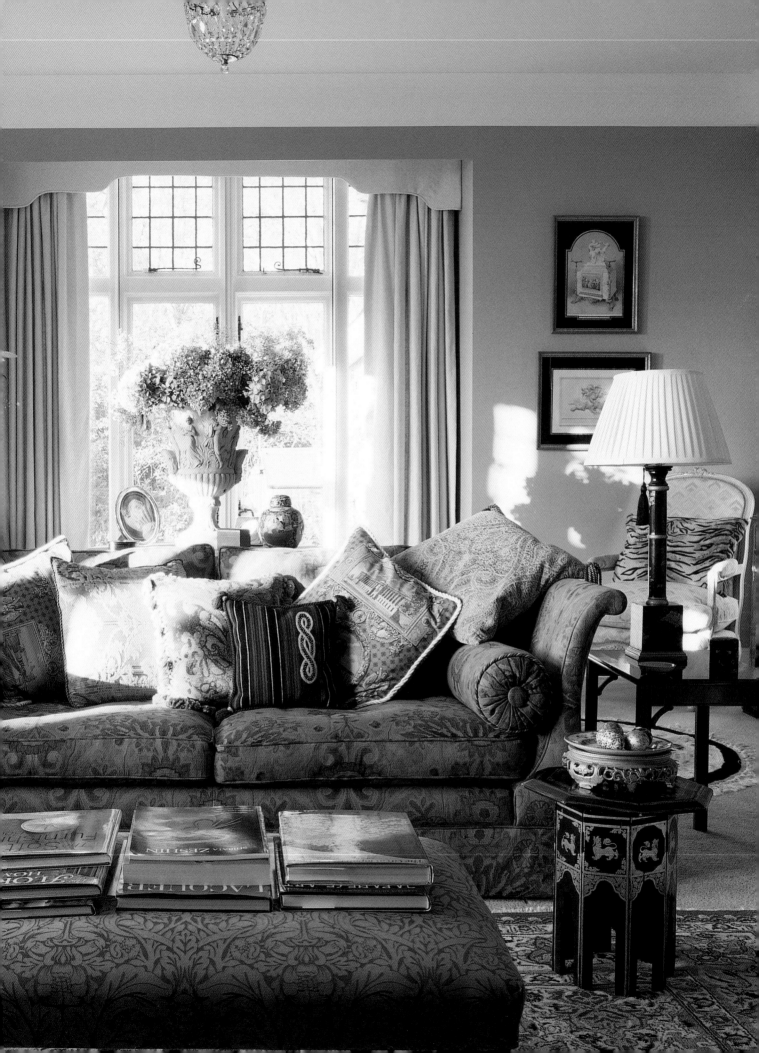

Luminescent **Tips**

•Decorating with mirrors illuminates your home. Hang them strategically to capture the light of glowing candles, sconces, and chandeliers. A Venetian glass mirror is well suited to a luminous interior. An enduring classic, the fashionable Venetian mirror is distinguished by the decorated and etched mirror frame that surrounds the central mirror plate. First designed to demonstrate the art and skill of Venetian glass makers in the 1600s, they were refined in the nineteenth century by the French.

•Arrange pillar candles in front of the fireplace and stagger heights with a variety of candle holders. Select candles in a variety of traditional tones from classic white to beeswax yellow to particularly enhance a luminescent room. Another option is a candelabrum behind or in front of a fireplace screen. Warm your hearth with a woven basket filled with wood, add decorative fireplace tools like a broom, poker, tongs, shovel, and stand.

•Once traded in the ancient markets of the East, prismatic glass beads capture light and add sparkle. Today you can select from an ever-growing variety of accessories that are adorned with tiny, glittering beads, such as beaded lampshades, votives, table cloths, place mats, pillows, and frames—diminutive jewels well suited to a luminescent decor.

•Bring true warmth to a luminescent decor with comforting throws that are equally at home on the sofa, chair, or ottoman. For chilly days and nights, envelop yourself in a lovely cream Angora or camel cashmere throw, switch to lightweight natural cotton in warmer months.

•Replace plain vanilla foyer or dining room light fixtures with an antique or flea-market find. . Use swing lamps on either side of a bed or strategically mount them by a club chair or sofa in the living room for reading light. Picture lamps, recessed lighting in shelves or under cabinetry, and halogen spots all create focal points with light. Install dimmers and low-voltage bulbs to instantly change the aura of a room from coldly stark to warmly glowing.

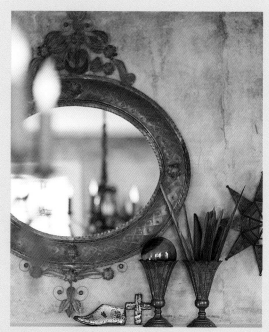

© Eric Roth

[ABOVE]
This mirror is positioned to reflect and maximize the radiance of a nearby chandelier.

[RIGHT]
Yellow and green mix to create the sunny disposition of this affable breakfast nook. Use yellow near glass exterior doors and in rooms with plenty of windows for an open, airy and undeniably cordial look.

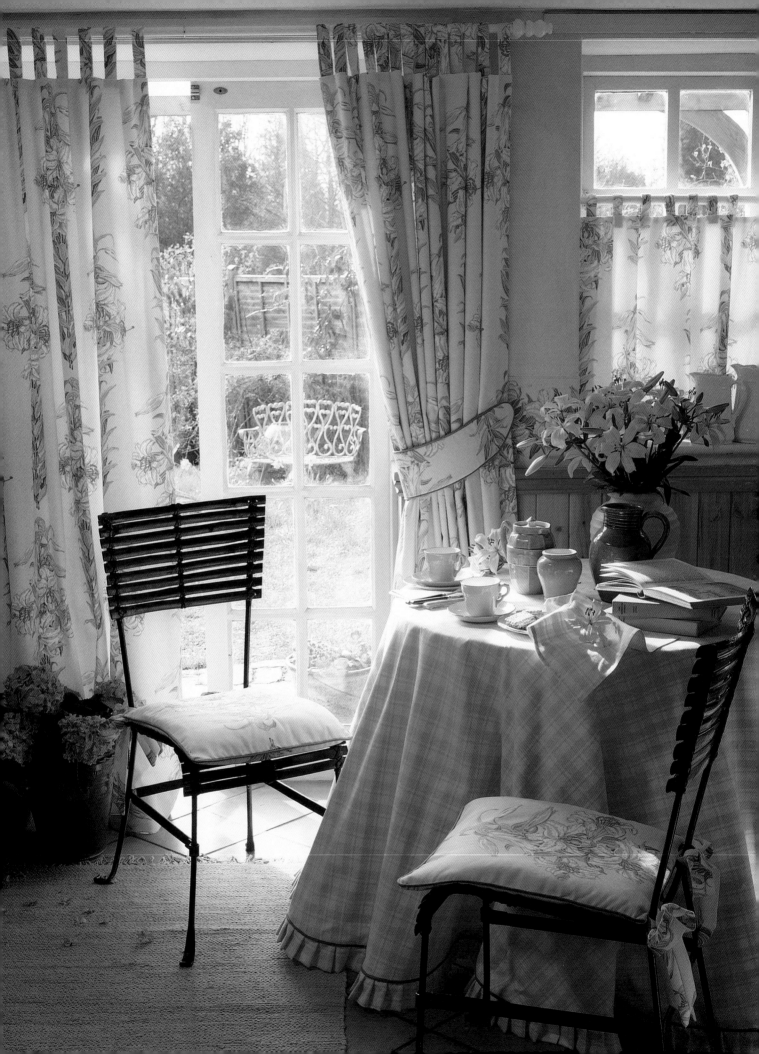

Tropical

Discover free-spirited tropical style and its brightest spark—outspoken lime green. Exuberant, effervescent, modern, and new, these yellow-enriched greens rejuvenate. The most carefree color of the traditional color wheel, chartreuse brings dynamic energy to any decor. This playful hue has a unique tendency to fall in and out of fashion; however, in a tropical setting this novel color retains its youthful strength, remaining current and crisp. Blend vivid chartreuse with an infusion of citrus-based hues, such as tangerine, shocking pink, and saturated yellow. Pair lilac with lime for a cooling combination. Flatter yellow-greens with natural colors like white, taupe, and rich chocolate hues. Spicy cinnabar and seasoned orange combine to bring heat to the freshest decorating color of the Pacific East.

A symphony of island-inspired materials, such as rattan, bamboo, hemp, and unpolished stone, merge and weave to construct a tropical decor. Fuse low, oversized furnishings and colonial-inspired antiques with Pacific island artifacts, darkly waxed woods, wicker accents, Asian-influenced batiks, embroidered silks, and primitive modern art. Use screens of translucent rice paper or carved wood to divide great rooms. Invite the outdoors in; leave windows unadorned to celebrate the semi-outdoor lifestyle of the islands or appoint with extra-wide 3- to 4-inch plantation shutters. To recreate the ambiance of a breezy verandah, mass potted tropical plants with infinite variations of fresh yellow greens.

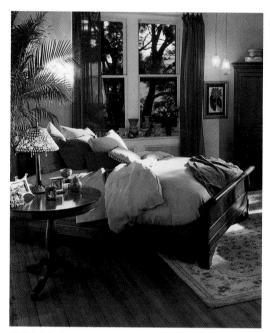

© Keith Scott Morton

[ABOVE]
Robin's-egg blue walls and magenta window treatments work together to heighten the rousing effect of chartreuse bedding, an Ottoman, and bedside chair. Sizable windowsills hold interior planters that are filled with flowers, beckoning the outdoors into the room. Two sconces illuminate a single framed print of a tropical flower.

[RIGHT]
This sophisticated room is filled with natural materials setting the pace for an unfettered tropical mood. A shallow bowl of pears, bleached wicker, modern mahogany, black lacquer accents, plenty of white and a dash of lime give this room its chic attitude.

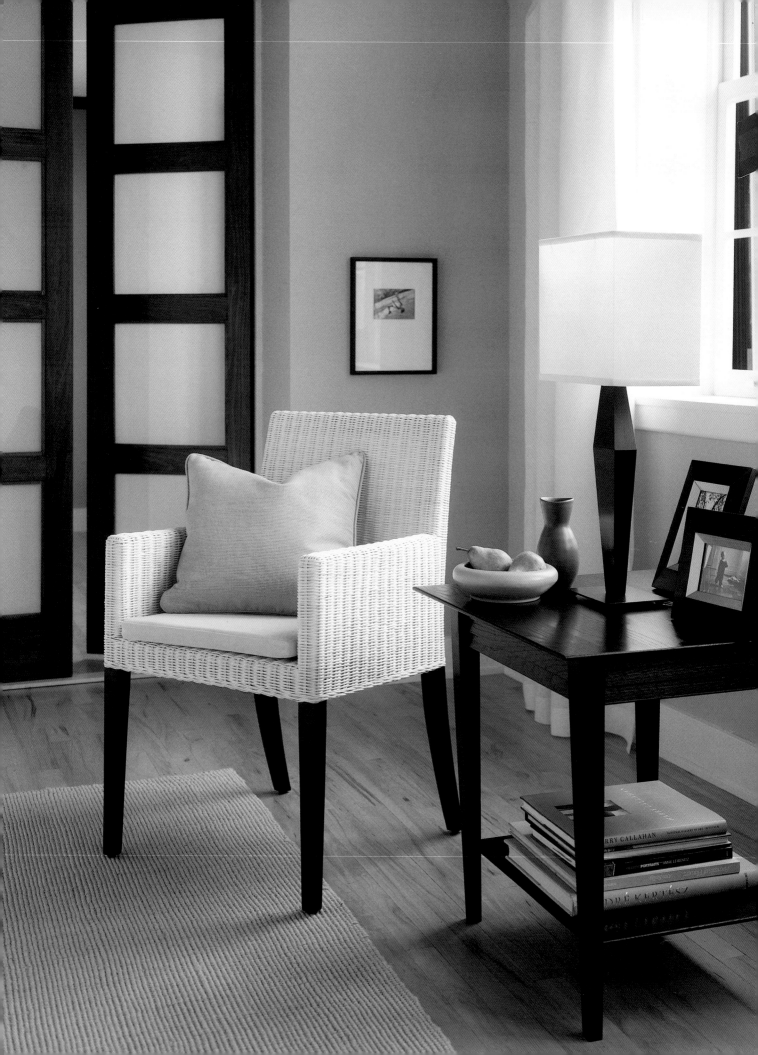

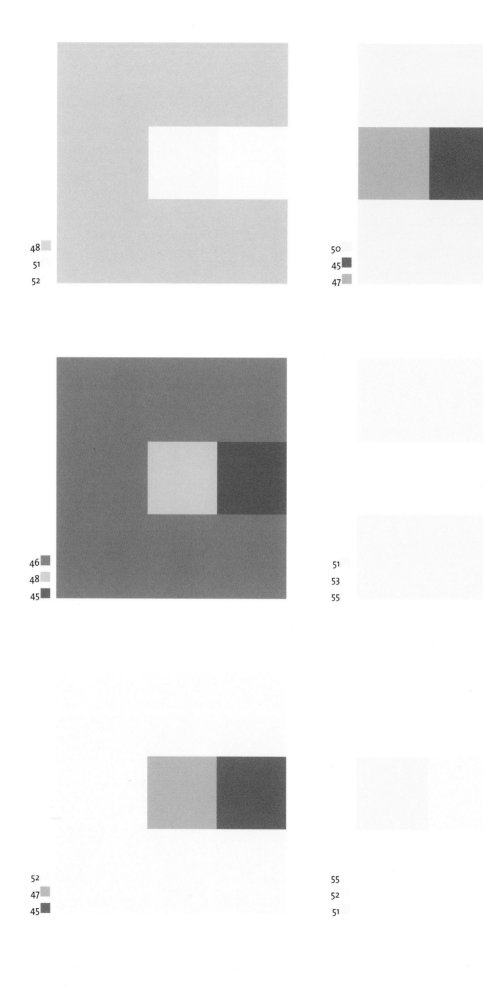

48
51
52

50
45
47

46
48
45

51
53
55

52
47
45

55
52
51

50
111

48
112

52
121

45
111

47
121

115
54

52
39
28

48
34
25

45
36
37

52
63
75

54
64
75

45
62
74

45
122

52
123

47
130

45
100

54
100

52
102

51
133

54
132

53
149

52
148

47
152

46
151

45
149

48
142

47
152

51
142

52
142

52
152

Decorating with a tropical mix

You may hear the call of island life when decorating with the tropics in mind. A tropical palette can be motivating and might herald a change toward a lifestyle that embraces semi-outdoor living. A tropical decor is equally at home with sleek, streamlined modern furnishings or traditional dark wood antiques. Tropical hues blend with other saturated hues, such as vivid magenta, spicy orange, and lemon yellow. The vibrant colors of a tropical color scheme work well with the deepest colors of the outdoors. Imagine deep forest greens, peaty dark browns, and evening-sky blues.

With pared-down furnishings, and greens as fresh and vibrant as palm fronds, this modern interior keeps the mood breezy and tropical.

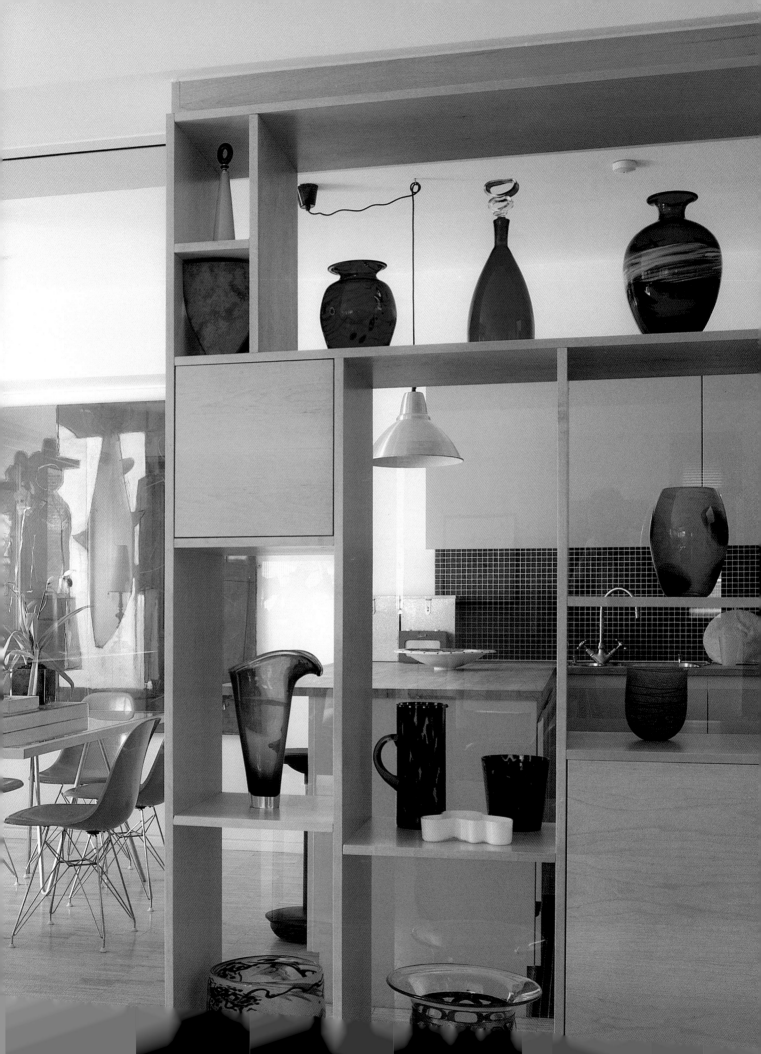

Tropical **Tips**

•Plant caladiums (an easy-to-grow annual tropical bulb) or low maintenance ornamental grasses, such as bamboo or pampas, outside windows for big, bold views of a tropical garden. Or simply place natural elements—perhaps an orchid spray—in front of a window to create a visual connection to the exterior view.

•Reconfigure a porch, sunroom, or large living area for semi-outdoor living by installing ceiling fans, screens, and natural stone floors that will weather. Outfit garden-style furnishings with weather-resistant cushions and pillows.

•At the end of your bed place a teak bench or lacquer chest, and add a thick cushion. Use this bedside nook to display extra pillows or blankets in chartreuse and complementary hues of vivid magenta.

•Consider positioning a bed in an unexpected area of the bedroom. Push a twin or full bed against a wall and pile it with pillows for a cozy day bed. Angle it toward the door or place directly in front of a vibrantly curtained window to create the illusion of an exterior view as a "headboard". To add drama to the "headboard" effect, select drapes in saturated hues of citrus such as lime, lemon or tangerine. As evening falls, shutter the window or pull down inexpensive bamboo blinds for privacy.

•Display travel-inspired collectibles, such as globes and outdated maps of exotic lands and faraway places in bamboo and dark wood frames. Position a standing electrical fan in black or stainless steel on a side table or atop a stack of travel books to provide gentle, "tropical" breezes in any room.

© Elizabeth Whiting & Associates

[ABOVE]
A generous arrangement of freshly cut flowers in citrus shades makes a lush arrangement that's brimming with tropical abundance.

[RIGHT]
Distinctive for their organic shapes and glazes that vary from green gray to olive to yellowy green these hand thrown vessels are inspired by the famed celadon pots of Thailand.

Tranquil

To connect with the tranquil outdoors and compose a home filled with peaceful serenity, use green—the color of life. Look to the living outdoors to find an infinite palette of greens from which to select, from youthful spring green to the intriguingly ancient colors of richly aged verdigris. Create a historical mood by deepening almost any green—leaf green, grass green, lettuce green, forest green. Achieve the eternal aura of an ancient forest by decorating with cast iron, carved stone, and garden statuary. Add a multitude of yellows from saffron to lemon for a sundappled blend. White and cream are two plain partners for green that soften and soothe. Energize the tranquil properties of fertile green with its most natural companion, earthen red. In addition, brown and gray blend and pair well with green. To link your home interior with the outdoors, there is no better color than green.

Alive and cooling, a tranquil palette brings the outdoors in. Discover that nothing brings new life to tired furnishings more than a color scheme that revolves around green. Mix spirited greens with pale woods to give the light and free feeling of summer; partner darkened greens with deep, rich woods such as walnut and mahogany for a mood of tranquil solitude. Bring outdoor furnishings in—use outdoor planters, fold-up furniture, plant stands, wooden folding tables, worn wicker, bamboo, bentwood pieces, director's chairs, hand-me-downs and other discards. Combine these new-found treasures with floral cottons, needlepoint or crewel pillows, and traditional "awning-striped" canvas cushions. Finally, begin to cultivate decorative elements such as a fascinating terrarium or two for decor that will evolve much like your own garden.

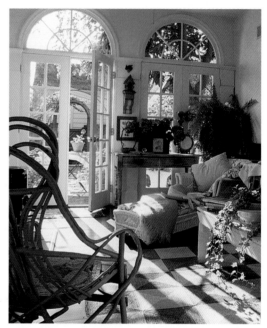

© Keith Scott Morton

[ABOVE]
An old painted bench serves as a lengthy coffee table in this tranquil, sun-splashed room. Plenty of cozy seating, pillows, and throws add to the comforting atmospherics. Note that the cushions are ever-so-slightly faded, and the worn furnishings have lovingly stood the test of time.

[RIGHT]
Arrange simple clay pots right on your kitchen counter if you don't have a windowsill. Paint tired wooden kitchen cabinets a cooling green to emulate a greenhouse environment.

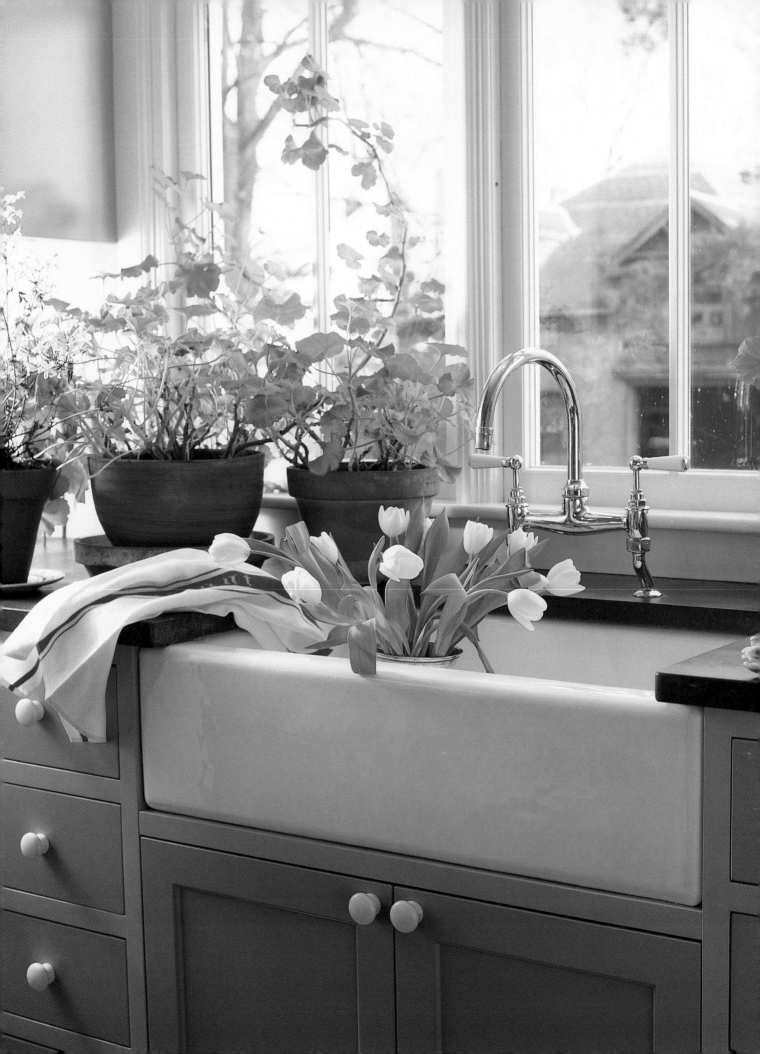

71
73
74

74
76
77

77
74
75

67
73
74

73
67
75

70
72
67

72
8

67
1

70
1

75
6

72
3

76
8

52
39
28

48
34
25

45
36
37

52
63
75

54
64
75

45
62
74

72
12

74
6

73
13

67
122

69
109

73
130

72
149

67
150

71
142

75
148

70
141

68
150

71
149

67
148

69
133

67
133

76
152

73
141

Decorating with a tranquil mix

Tranquil interiors are mood enhancing and nurturing. A cool palette will blend comfortably with a wide assortment of furnishings and often feature a variety of greens, one of nature's most abundant, peaceful colors. Red, the most stimulating color, is green's color wheel opposite. When used sparingly, a bit of red will bring interest and energy to a tranquil color scheme.

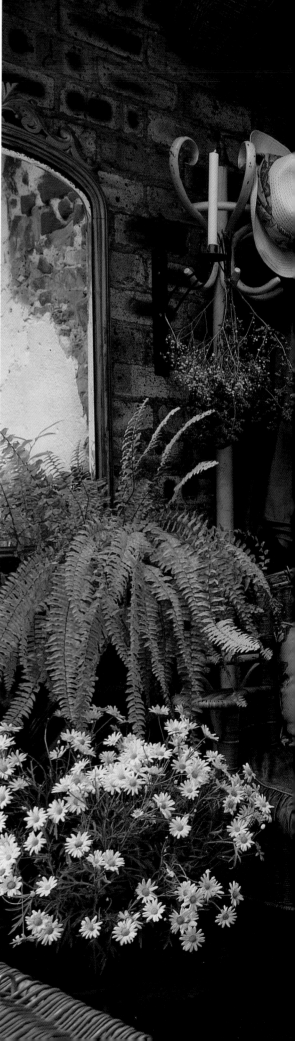

A room needn't be flooded with light to create a tranquil garden mood. Mix seasonal plants like these daisies with hardy indoor varieties. Highlighting an exposed brick wall or mural adds to the indoor garden atmosphere.

© Abode UK

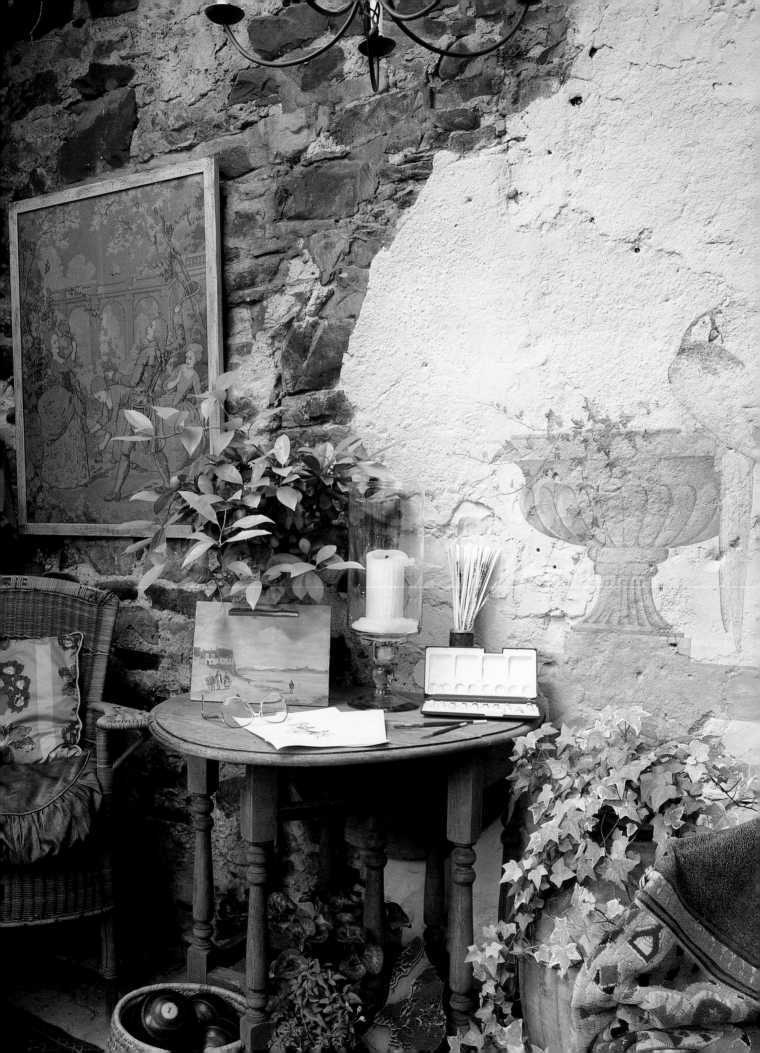

Tranquil **Tips**

•You don't need to own a conservatory or greenhouse to create a garden environment. Maintain the mood of your tranquil interior by selecting indoor plants that reflect the seasons. Throughout summer, feature potted plants such as hydrangeas, begonias, impatiens, and periwinkle. For autumn, pot ornamental kale; in early winter, fashion branches with berry clusters into sparse wreaths; anticipate early spring by planting bulbs such as amaryllis, crocus, and hyacinth.

•If the room you are decorating is accessible to an outdoor garden, select a floor covering that's durable and easy to clean, such as laminated wood or oversized tile. Select from warm woods and stone floor coverings with a hint of red (the complement of green) to bring a rich, rustic undertone to a tranquil environment.

•While a chandelier lends romance to a garden-inspired environment, it may not be practical. A ceiling fan is a functional choice when cooling is critical. Add a light kit and install a dimmer for controlled overhead lighting.

•Take inventory of your current possessions and tap into your own indoor garden style. Random purchases, family keepsakes, even questionable college acquisitions, can have a second life when painted, restored, re-covered, or recycled with various tints and shades of peaceful green.

•Display vintage bird and botanical prints, accumulated belongings from travels, antique wooden farm tools, or perch a row of bird houses atop a mantel.

•Salvage and reclaim a collection of containers—from coffee cups to odd glassware—to accommodate a kitchen herb garden beside a sunny window.

•Consider investing in a classic solid teak bench, occasional table, ottoman, or chaise lounge. Beautiful indoors and out, teak is a durable, weather-resistant wood. To achieve a silvery gray patina that will pair beautifully with garden green, simply leave the furniture outdoors to age.

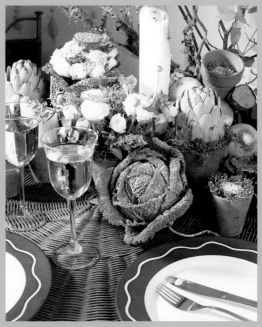

© Abode UK

[ABOVE]
A grouping of assorted terra-cotta pots planted with artichokes, white flowers, moss, and cabbage with candles nestled inside makes an unstudied centerpiece for a casual gathering.

[RIGHT]
Flavor and infuse oils and vinegars with your freshly harvested garden herbs for cooking and display.

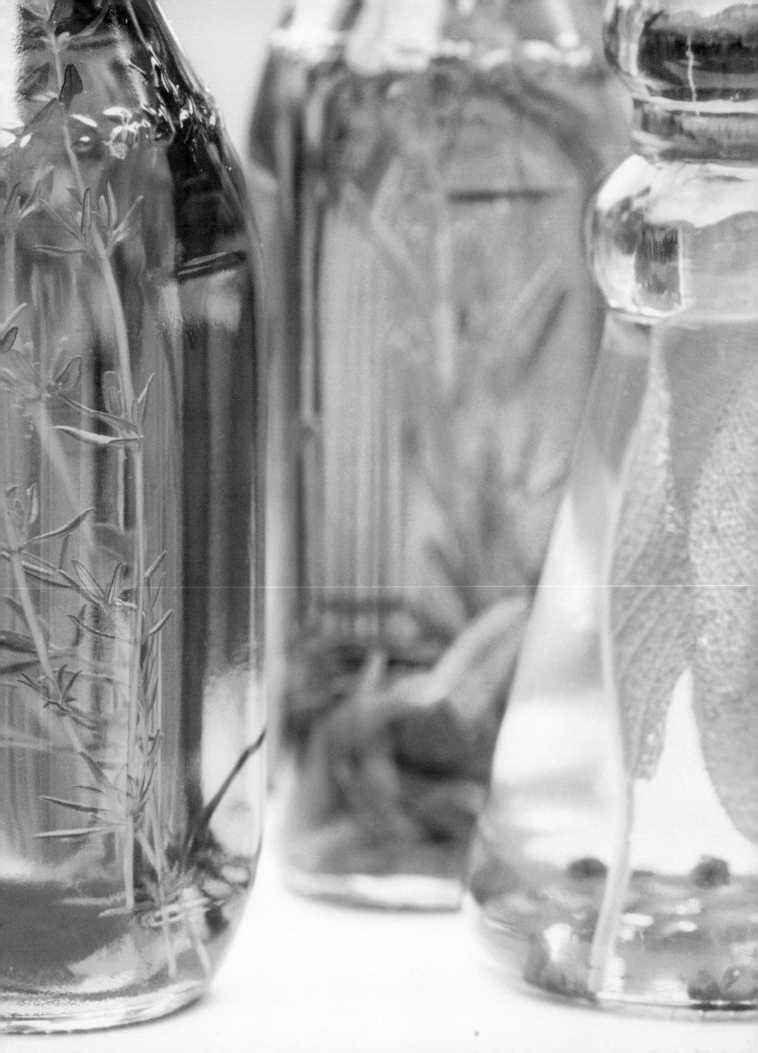

Coastal

Coastal colors not only refresh and invigorate, these hues originating in air and water are positively buoyant and restorative.
From watery pale aquamarine to the dark blue-green of a stormy sea, these cooling hues are traditionally used in oceanside decor. Seek the colors of this palette for their renewing properties. A variety of ultramarine hues are rejuvenating, uplifting, crisp, clean and ever-popular for the bath and bedroom.

Pair watery seascape hues with driftwood silvery grays, cooling whites, and grayed blues for a marine-inspired decor that also adds restraint. Mix with true blues, navy, and emerald green for an analogous approach. Touches of complementary coral and sandy orange will enhance and give complexity to this soulful color scheme that is never quite out of fashion.

Coastal colors are easy on the eye and a breeze to use when decorating. They appear to blend and recede much as the tide. For fabrics that inspire coastal living, select from bold stripes, cotton duck, hard-wearing terry cloth, and simple checks. Tiles in various shades, thickly bound sisal, nautical accents, as well as a variety of furniture styles serve the colors of the sea well. With this palette it is easy to create an informal attitude, casual and light—your own fusion of sea and sand and sky.

© Laura Ashley

[ABOVE]
Mix and match an assortment of linens for the bed, bath, and kitchen, such as this light and airy stack of white, yellow, and blue-green patterned sheets, coverlets, and bedding.

[RIGHT]
Multi-colored tiles with slight variations in color in the bath evoke the soothing mood of the sea just as the marlin mosaic reflects its energy. Try an assortment of tile sizes and shapes for a flowing, rhythmic effect.

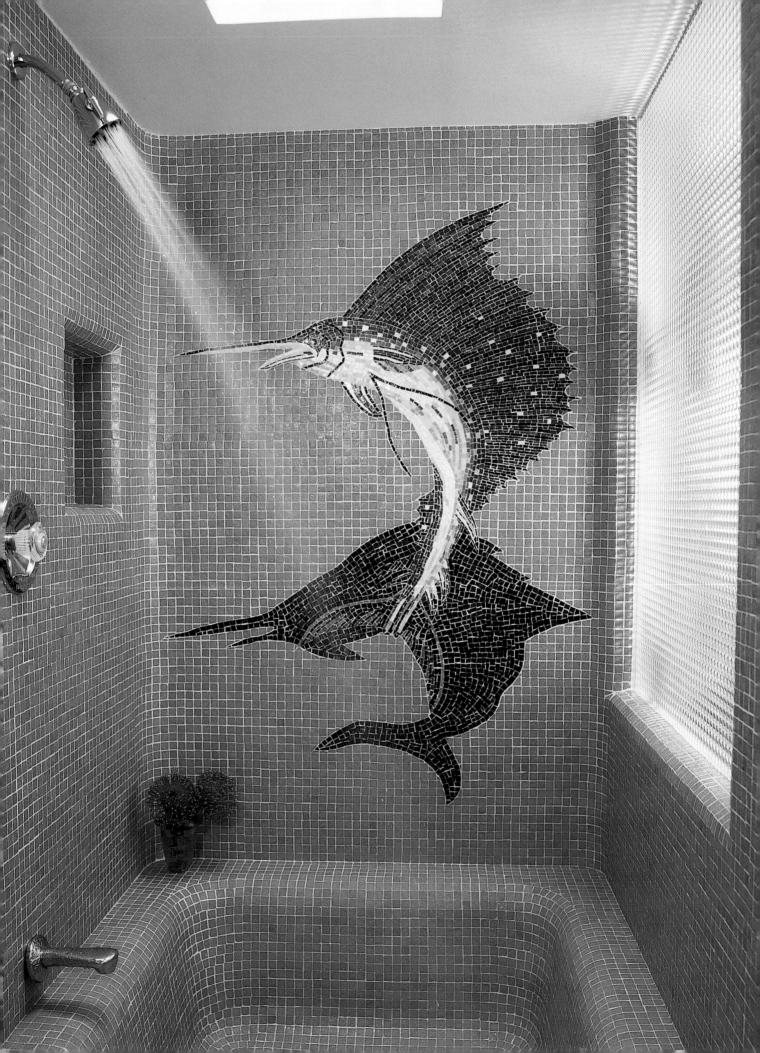

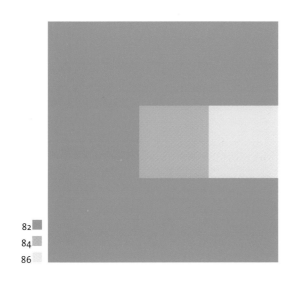

82
84
86

88
85
78

78
85
84

80
88
86

81
83
79

87
86
85

84
13

78
17

82
16

78
13

88
19

88
22

82
95
108

84
97
109

78
96
107

86
74
63

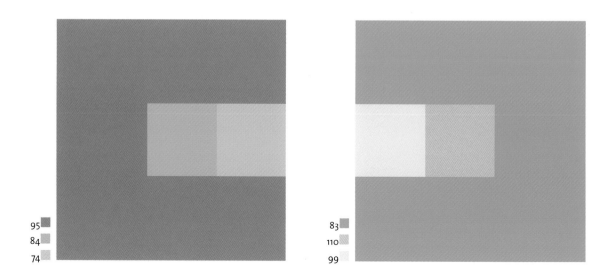

95
84
74

83
110
99

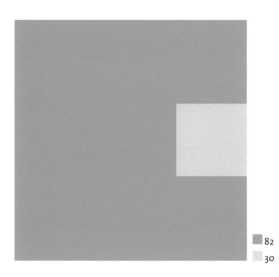

82

30

80

26

78

23

78

1

82

6

85

8

82

133

80

135

78

133

79

145

84

134

82

142

81
146

78
145

79
149

81
152

85
149

86
150

Decorating with a coastal mix

A coastal palette is transforming and cooling. Impressionistic hues and ever-changing coastal colors alternately stir the spirit and offer a calming port. This palette can be lightened for summer and deepened for winter. Its cool tones bring a quiet, restful mood to any decor.

Pair a coastal mix with antique pine furnishings, flea-market finds that have been freshly whitewashed, or contemporary furnishings with clean lines. Coastal tones blend well with other planet based colors such as a pearly blue, grass green, dusky gray, and berry red.

Soft, comfortable bedding featuring aquatic colors with tidal designs that embody the renewing qualities of a coastal environment. Replenish your soul with nearby books, a journal, and a sketchpad.

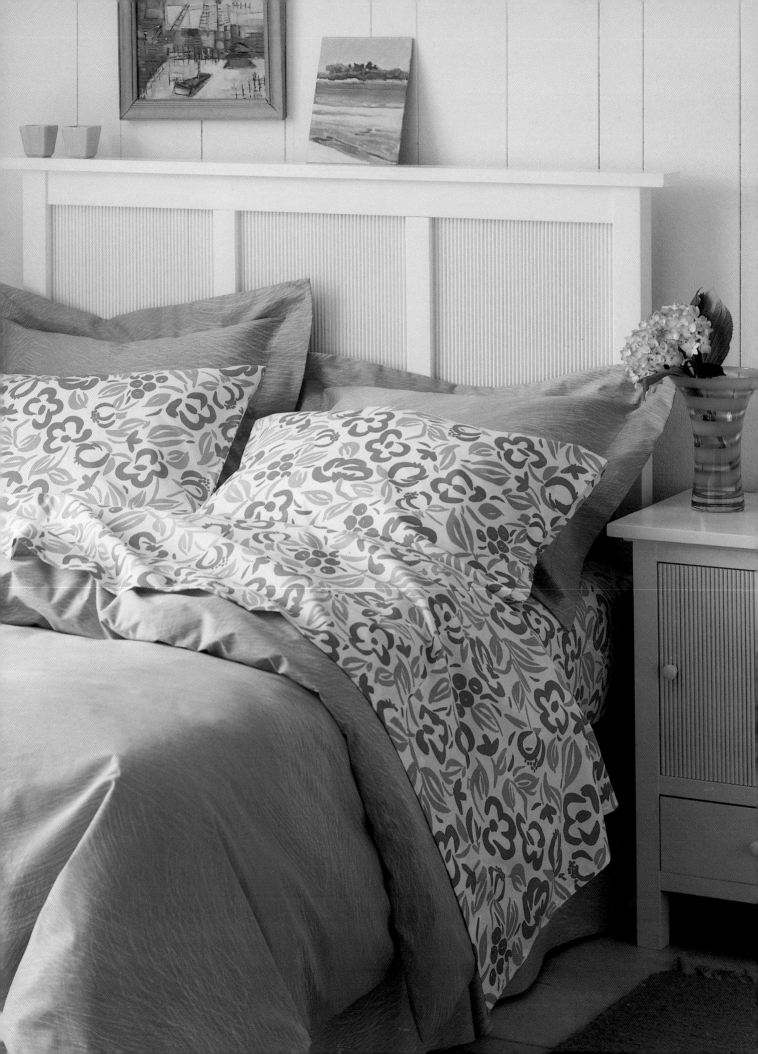

Coastal **Tips**

•Transforming and cooling, the colors of the sea may be the most consistently available and versatile. To avoid the look of perpetual, summer use grays, deep seaweed green, and peaty moss hues for soft furnishings in the winter months. Lighten with translucent watery hues as spring and summer return.

•The catch is not to give in to the cliché of seaside living, with shells and starfish abounding. Think strategically when using nautical accessories: a little can go a long way.

•Think of how you live before you accessorize and anticipate your needs. Places stacks of well-worn novels near the bed, display candles and small luxuries in the bath, hang kitchen dish towels near the sink on homemade shell pegs, and even keep classic board games handy on a coffee or sofa table.

•Mix fabric patterns such as stripes, florals, solids, and checks. The key is to look for one or two common colors such as teal and emerald green that will unite the variety of patterns. Wash your bedding and comforters (over and over and over) for a seaworn coastal look that's lived in, soft, and cozy.

•Paint paneling, bookshelves, storage cabinets, and furniture to achieve a casual, custom look. If your wood floor is old and damaged, consider painting the surface a crisp dove-gray or oyster-white to anchor the luminescent turquoise of the sea.

© Tim Street-Porter

[ABOVE]
Multi-colored tiles with slight variations in color in the bath evoke the soothing mood of the sea. Try an assortment of tile sizes and shapes from small to medium, rectangular and square, for a flowing, rhythmic effect.

[RIGHT]
Create a coastal still life with translucent glassware accents such as a cobalt blue vase and a hand-blown glass pitcher grouped together with bath salts and potions in clear and frosted glass bottles.

Classic

Possibly the most classic color for interiors is blue, a color so beloved it's nearly everyone's favorite hue. More cozy than formal, like an over-stuffed wing chair, blue is the most comfortable classic. Charming and sentimental, classical blue is a time-tested favorite for kitchens, guest rooms, and formal living areas. Blue almost always harmonizes with other blues. Cornflower blue, steely gray blue, and dark navy blue all blend and merge to create the contemplative mood of blue. Mix gentle shades of indigo and lavender to enjoy the nostalgic sweetness so typified by blue. Mix blue with the most luminous color, yellow, for an uplifting, whimsical mood. Enliven a sedate blue with its complement, orange, whose tints and tones restore equilibrium to a blue decor that has gone cold by bringing brilliance and luminosity to this cooling hue.

At its most unpretentious, blue is a work horse. Imagine deep denim and chambray paired with dark waxed woods, fruitwood, or pine. Natural hues like oatmeal, ivory, and nutmeg temper a variety of blues, from dark navy to brilliant sapphire. Simple printed cottons, linens, florals, paisleys, tiny prints, woven jacquard, sheer fabrics, and laces all work nicely with time-treasured blues. Mix with sage greens and berry colors for the mood of an English garden. Warm blue with rosy pinks, reds, and rich brick hues. For furnishings, select cozy sofas, oversized love seats, high four-poster beds, and upholstered ottomans and footstools.

© Laura Ashley

[ABOVE]
Combine classic blue with sage greens, purply blues and creamy oatmeal hues to create a decorating mix that's not only historic but refreshingly modern.

[RIGHT]
A tradition of decoration revolves around the classic combination of blue and white. Select from a variety of English inspired fabric patterns for a room that's both refined and homey.

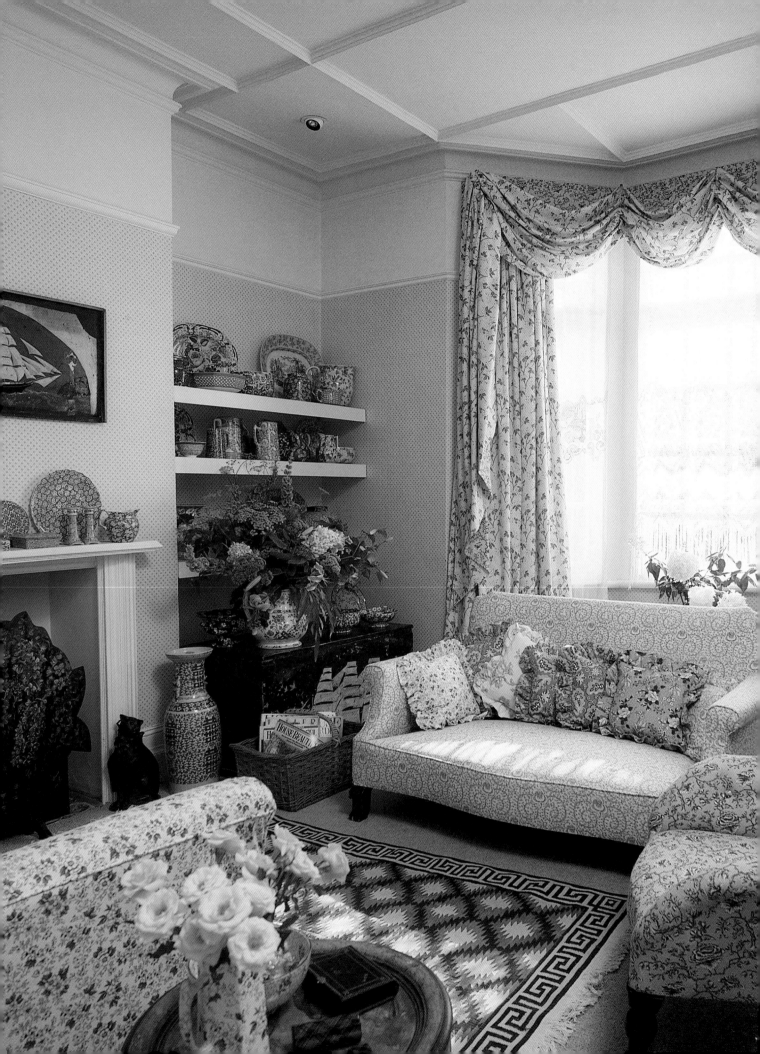

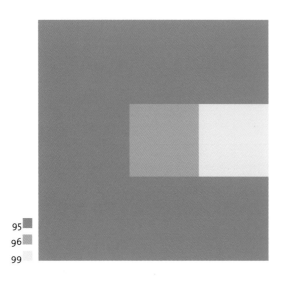

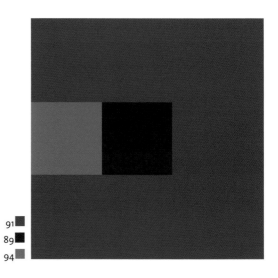

93
95
97

89
94
96

95
96
99

91
89
94

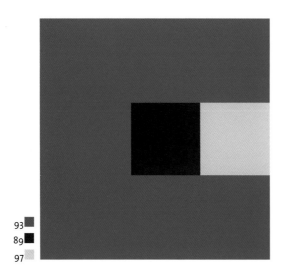

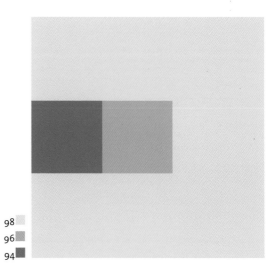

93
89
97

98
96
94

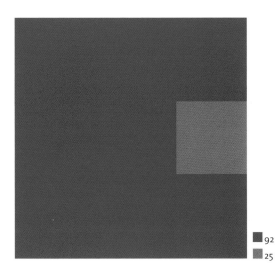

92
25

89
24

94
26

96
28

90
31

93
30

91
112
101

93
103
115

89
106
116

90
105
84

95
109
85

94
82
72

93
41

90
40

94
36

93
20

95
12

89
14

92
133

90
148

91
145

94
136

89
142

93
141

92
149

91
148

89
145

96
148

98
150

96
151

Decorating with
a classic mix

The color of the newest star and as expansive as

the skies, blue emanates visual lightness.

Airy and calm, a blue color scheme is a truly

classic foundation. Blue is the centerpiece of

countless palettes that are at home with a

variety of historically inspired fabrics and

furnishings. Serene and spacious, a room that's

decorated with blue exudes a sense of order and

well being. Lend a bit of history to any space and

decorate with timeless and true blue.

Earth hues surround and heighten traditional blues.
For example, a natural jute rug paired with lightly buffed
terra-cotta walls provides a neutral backdrop for this
blue-centered room.

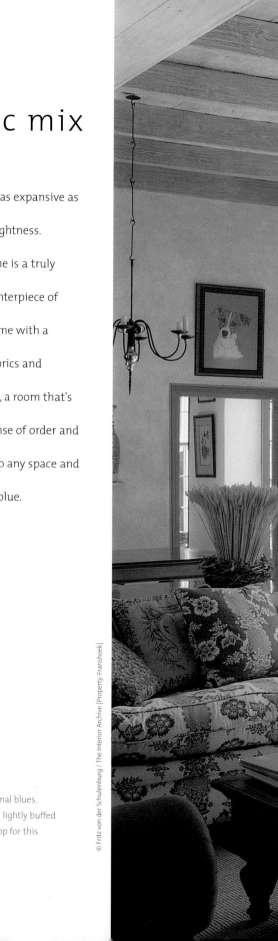

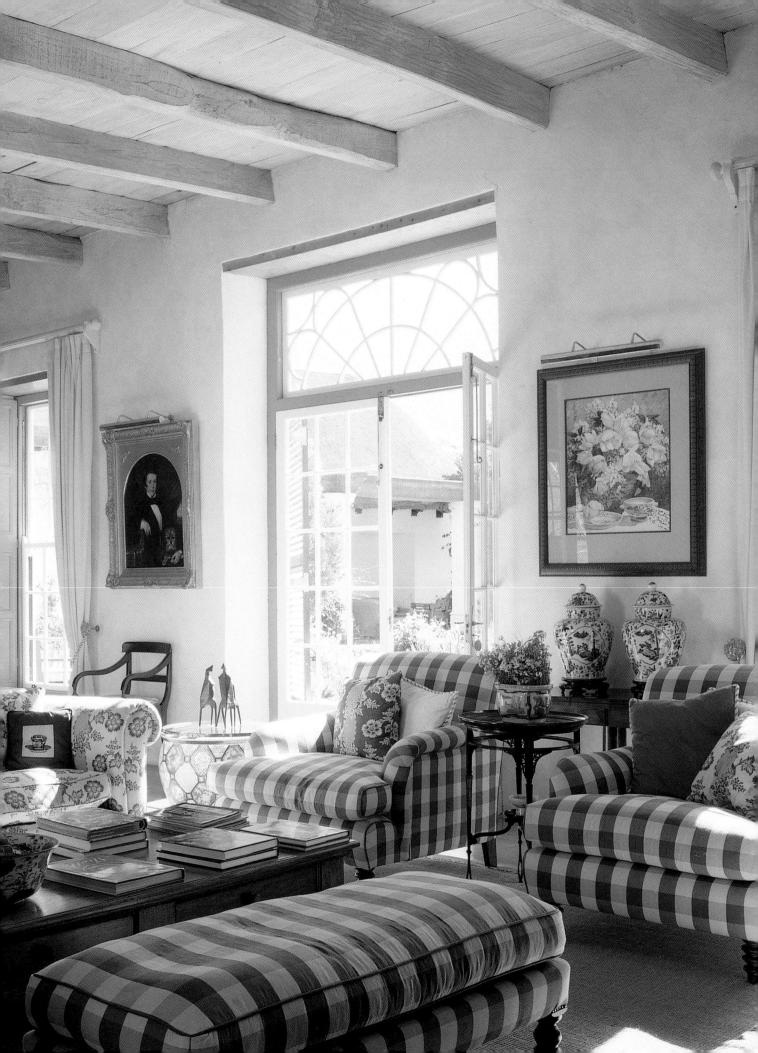

Classic **Tips**

•Scandinavian decor often employs a dove gray blue to heighten architectural accents. Consider painting trim and moldings a light steel blue. Or paint the ceiling of an interior room or an outside porch a softly muted sky blue. The blue surface will recede to give the illusion of a celestial sky.

•Table lamps add warmth and light to classic decor. In a bedroom, replace old lampshades with pretty printed fabric shades, or use classic creamy solid shades in a living area. Column-style metal bases or simple wood candlesticks make sturdy traditional lamp bases.

•Throughout the ages it has been believed that blue keeps flies away, explaining why it's the most classic color for kitchens. Bring blue to your modern kitchen—arrange and hang a collection of porcelain blue plates with intricate designs and illustrations; display cobalt blue glassware; paint kitchen niches and cabinet interiors a soothing robin's egg blue; or add a tile backsplash of handpainted delft blue tiles. Select stool and chair cushions in blue-based fabrics that feature traditional patterns like cotton gingham, blocky checks, and bold stripes.

•Pile soft sink-in sofas and four-poster beds with wonderfully embellished pillows. Choose classic designs, such as fleur-de-lis, coats of arms, and heraldic motifs. Collect needlepoint and tasseled velvet plush pillows for old-world style.

•Search through discarded wallpaper books and at antique stores and flea markets for botanical, vintage bird, and large-scale floral prints. Frame in gilt, bamboo, or distressed painted frames. To determine placement, first arrange them on the floor and then hang on the wall as a decorative group.

•Many flowers have blooms of blue, such as modest pansies, blue bonnets, and delphinium. Since budding blues are more challenging to find in the winter, try a dried arrangement of silvery blue hydrangeas and lavender. If you prefer a living display, plant masses of lilac blue hyacinths in a shallow bowl for bell-shaped blooms from the chilly season to early spring.

© Fritz von der Schulenburg / The Interior Archive [Designer: Andrea de Montal]

[ABOVE]
A prized collection of china is presented three ways: hung on the wall, stacked in an architectural niche, and casually arranged on a wall shelf for a charming display.

[RIGHT]
Decorate a kitchen with whimsical checks of blue, white and accents of violet.

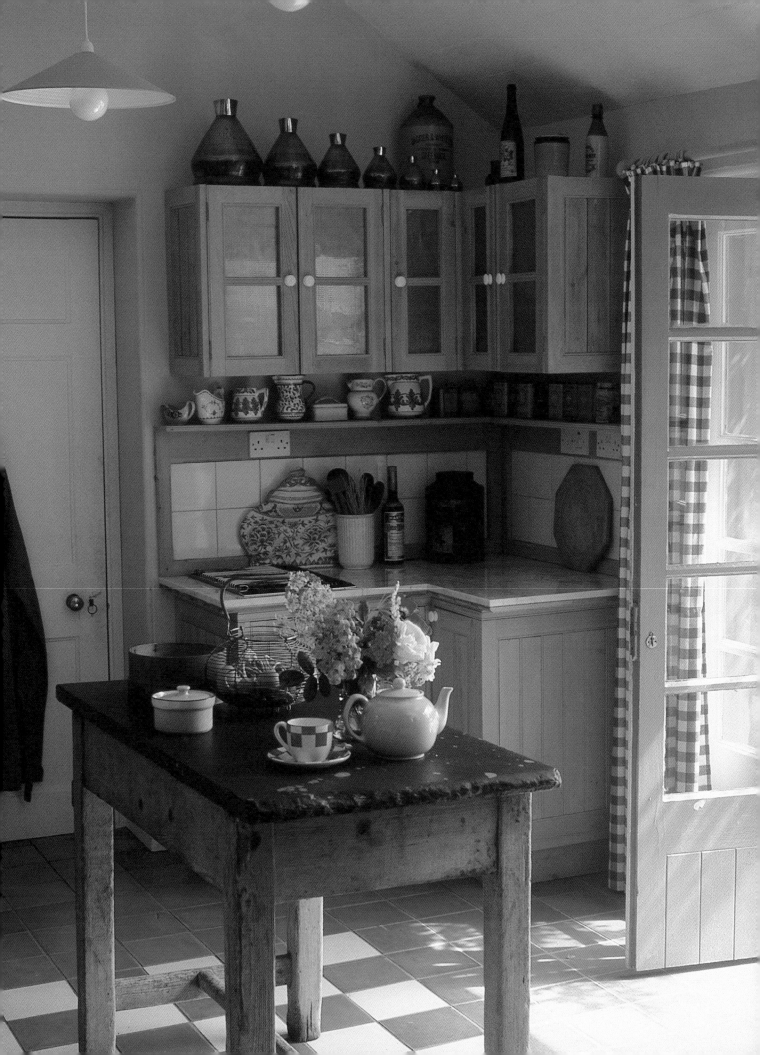

Icy

Pure and elemental, an icy palette is modern and clean. Like the first gust of winter, even the softest cool violet palette is a bracing reminder of the color of sunlight as it plays upon ice and snow. At its deepest saturation, blue-violet is boldly expressive, becoming mysteriously inviting when small doses of black are added to its intense indigo hues. Mix this glacial color with shiny chrome and glass accents, and add steely dark grays for a contemporary feel. Combine with red-based purples and magenta for a warm yet still modern mood.
Balance the crispness of an icy color scheme with natural background hues like oatmeal, buff, and ecru. Add the smallest touches of aquamarine and chartreuse to uplift and energize any blue-violet scheme.

Cool violet is a Spartan hue that reflects holistic living and inspires meditative decor. Use pastel tints of this elemental hue to showcase austere spaces. Redefine the infamous great room popularized in the 1970s with an arctic color palette. Translucent fabrics, synthetics, and plastics fuse with concrete and polished pine for a look that will be tomorrow's classic. Select an eclectic mix of vintage finds and futuristic furnishings, such as angular furniture of metal and wood, fabrics that feature geometric patterns, and spherical lighting. Modular Scandinavian and Danish furnishings give an icy interior its edge—look for shelves that double as room dividers, linear storage units, and free-floating platform beds.

©Red Cover/Andreas von Einsiedel

[ABOVE]
Mix soft gray blue with silver and marble decorative accents to create a bath with a cool, tranquil atmosphere.

[RIGHT]
Use the palest icy blue to outline and emphasize architectural features, such as this stairway and rails. The warm tones of a chocolate brown carpet and an antique fruitwood side chair, the perfect complements to a cool blue palette, soften the Spartan lines of the space.

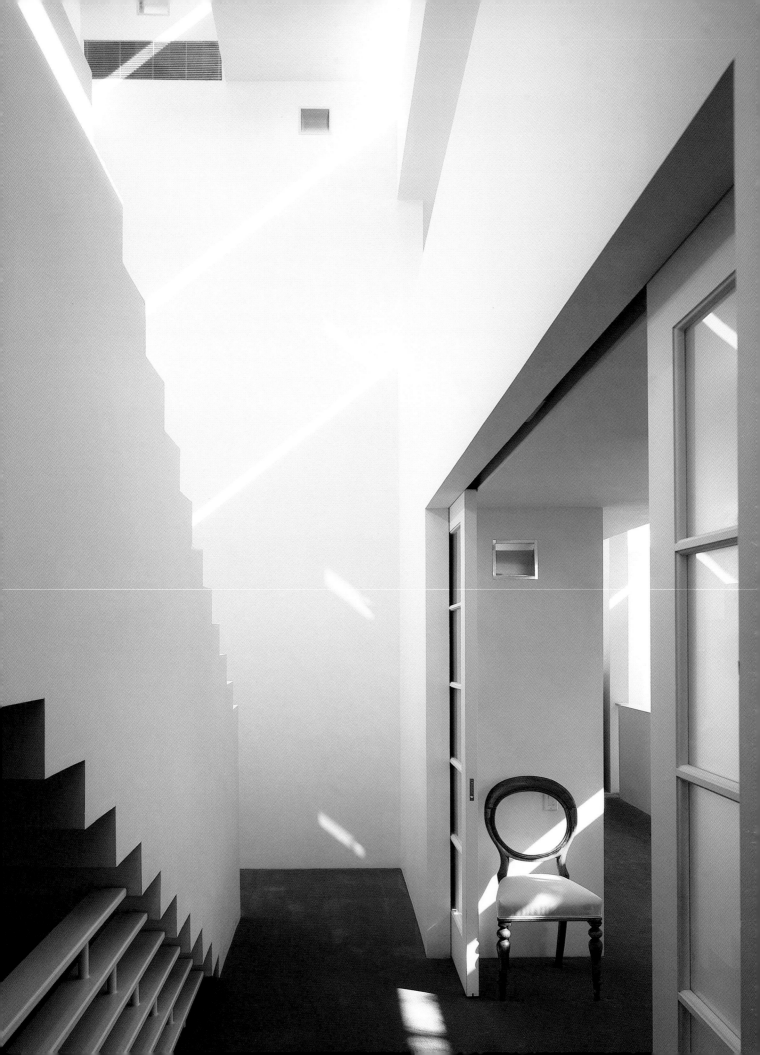

104
102
100

101
105
107

105
103
100

107
106
108

108
107
106

110
107
105

105
141

100
34

102
36

107
44

108
40

110
34

104
115
126

107
112
123

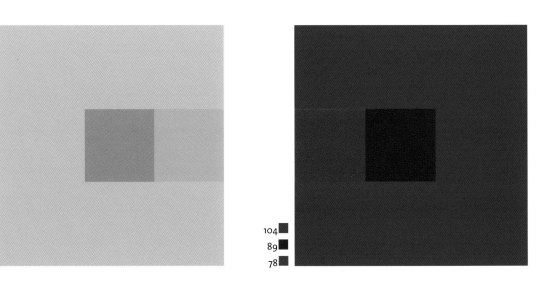

110
118
129

104
89
78

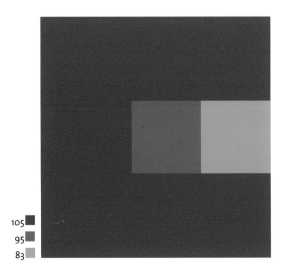

105
95
83

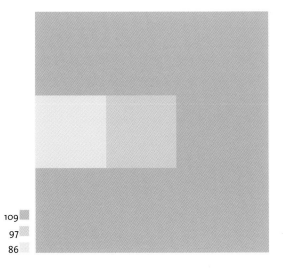

109
97
86

■ 105
■ 47

■ 102
52

■ 100
■ 45

■ 101
■ 25

■ 107
■ 29

■ 110
32

104
133

106
146

107
147

109
149

110
148

107
145

107
142

105
152

100
149

103
142

106
142

100
152

Decorating with
an icy mix

A frosty decor is a balance of clean lines and cooling color delicately weighted to create a soothing, contemplative atmosphere. Icy interior design is both forward-looking and retrospective, featuring sleek mid-century references, such as newly interpreted fabrics and vintage accessories. It's crisp, clean, and glassy, with an ability to work on a large or small scale. Icy hues modernize and are a good choice to revitalize ho-hum spaces, enlivening everything from galley style kitchens to cavernous great rooms.

Natural pines and metals offset this cool blue-violet flooring, furnishings, and accessories in this spacious living area. Linear metal and wood shelving serve as a functional divider in this open-air room.

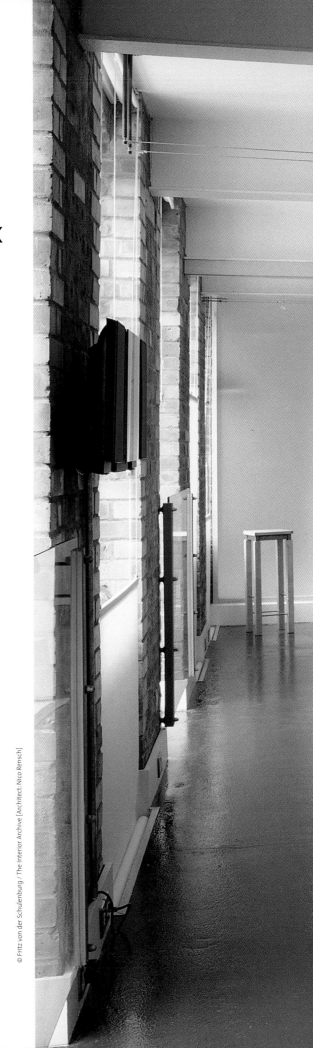

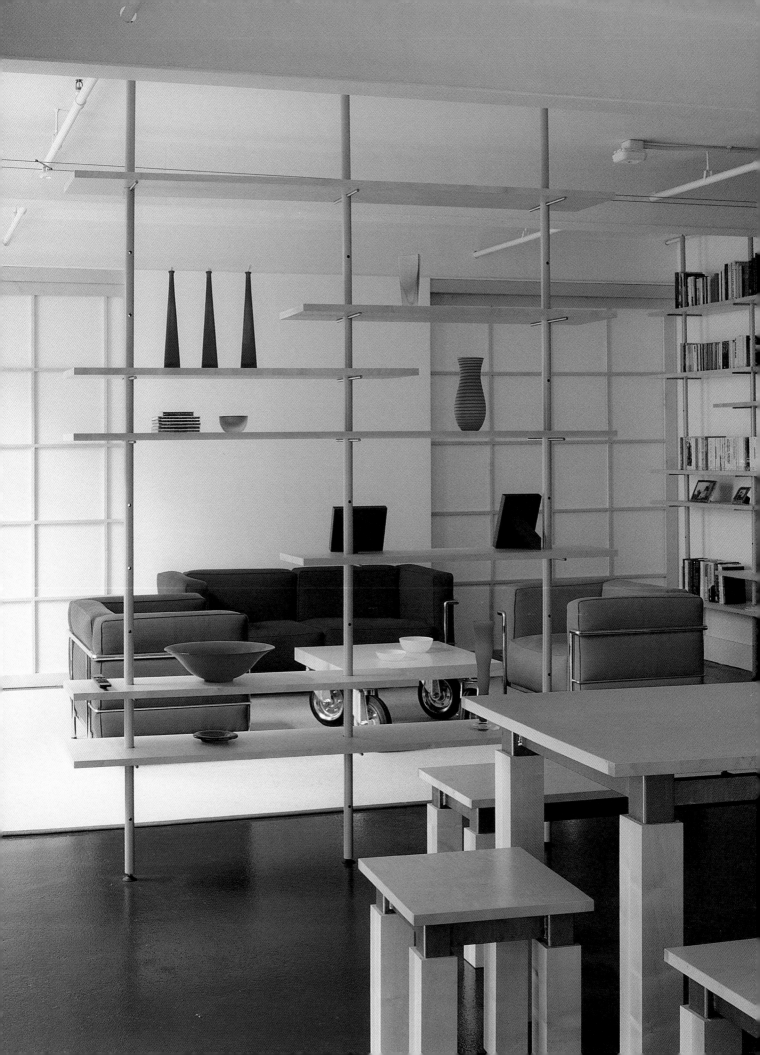

Icy **Tips**

•Choosing stainless steel surfaces for kitchen appliances instantly gives professional restaurant style to a home kitchen . To refine this crisp, industrial look, consider mounting a backsplash of economical glass (paint the back surface of the glass ice blue after it's cut and beveled to your specifications) or select from a wide array of cooling metal laminates and solid metals designed for vertical surfaces. Metallic surfaces bring a slick modern crispiness to any room especially when variations of blue-violet hues and tints are chosen.

•Modern kitchens are efficient. Glass suspension shelves that secure with cables create parallel storage that's instantly accessible. Hang several rectangular or corner shelves to keep cooking staples at your fingertips. Use sleek metal or glass countertop containers for items you cook with daily. Plan specialized work zones for favorite activities like baking by grouping mixing bowls, pastry bags, measuring cups and spoons in one area of the kitchen.

•Cultivate an icy scheme by displaying blue-violet irises and hyacinths in clear glass containers. Plant four to six bulbs in a 4-inch plastic pot; once shoots are established and reach 3-4 inches, wash the potting soil off of the roots and replant in parfait glasses or recycled jars for a dramatic view of blooms and tangled, exposed roots.

•Combine icy blue-violet colors with the classic clean lines of furnishings designed by mid-century modernists. These design classics will never go out of fashion. Invest in one or two of the "real things" and build a room around a pair of Mies van der Rohe's Barcelona chairs. Keep the mood stark and clean with simple additions, such as a woven hemp rug, a thick glass-topped coffee table, and the clean-lines of a tuxedo couch.

•Use light tints when painting expansive interiors that feature multiple windows. For example, paint the walls of a great room a very light ice blue to create a spacious environment for daily life. Enrich smaller interior spaces like a small foyer or guest bath by painting with a mid-value violet hue.

© Elizabeth Whiting & Associates

[ABOVE]
An unusual backsplash of icy blue glazed tiles and the surprise of a deep blue-violet window trim and table top combine to create an eat-in kitchen that's fresh and modern.

[RIGHT]
Keep dark colored walls icy by adding stark white accents. Here, the crisp look of vases and mirrors cools the room and adds dimension and visual interest.

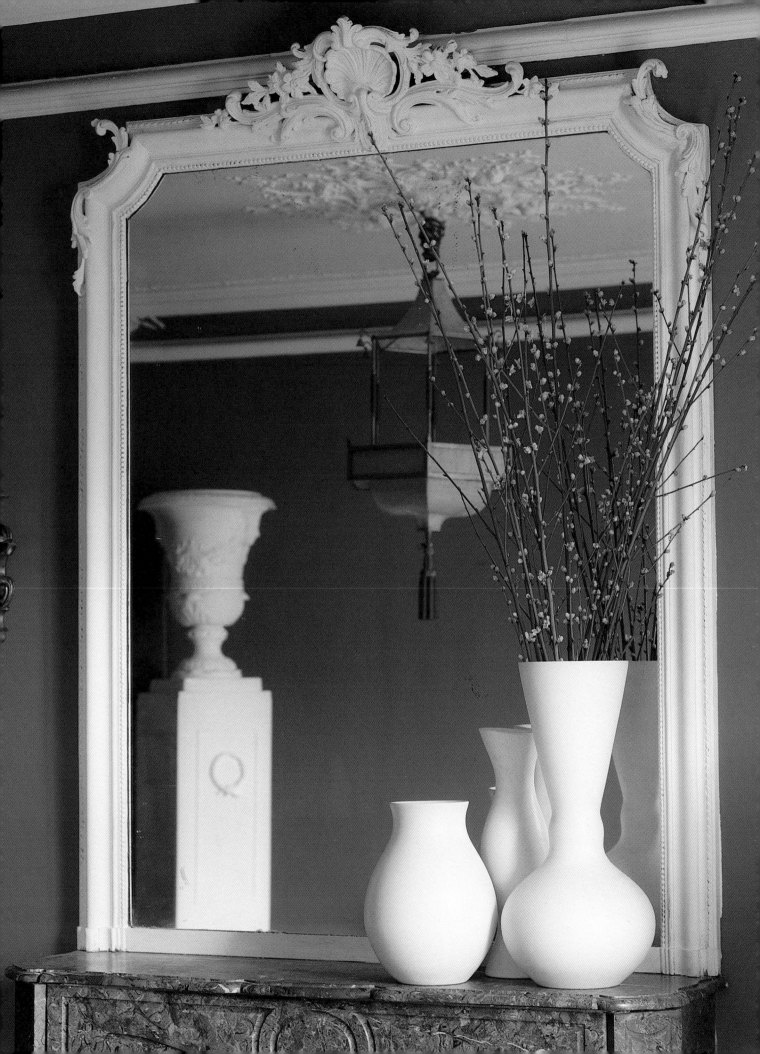

Luxurious

Surround yourself with elements of luxury to transcend everyday life. Pamper yourself and create a decor full of luxury and abundance that speaks to you. A palatial hue, violet moves, sometimes imperceptibly, between warm and cool. Push the limits of monochromatic decorating and combine warm amethyst-red purples with clean, clear violets that have a bluish base. To achieve an almost royal air, blend violet hues with their natural partners, shimmering metallic hues like copper, bronze, and gold. Mix violets with saffron, mulberry, and turquoise for a tapestry of richly hued color. Combine luscious mauves with a variety of greens from sparkling emerald to calming jade. Seek harmonious combinations, such as restful silver gray and pale lilac—they will promote and enhance a lush, meditative mood.

A luxurious interior is the perfect setting for gleaming dark woods, curvilinear furnishings, chaise lounges, corner chairs, and traditional furnishings. In a luxurious environment, much of the decorating fun is to choose pieces that are ever-so-slightly over the top—like a Victorian settee or an ornately carved Middle Eastern chest. Window treatments, a major focal point in any room, can be quite simply grand within a luxurious interior. Be generous with fabric, and then gather, bunch, or swag even simple tab or pencil pleat curtains for an opulent result. Consider the effects of tiebacks, valences, cornice boards, or elegantly scalloped blinds used alone or in tandem with curtains. Invest in a luxurious interior by selecting glamorous fixtures like a crystal chandelier, or embellish with more modest (albeit thoughtful) touches, such as neck rolls positioned at each end of an overstuffed and tufted couch.

© Laura Ashley

[ABOVE]
Pillows, pillows, and more pillows. These plump, plush gold and indigo-hued pillows festooned with tassels, trim, and piping pair well with purply hues.

[RIGHT]
Dress a bed with an abundance of velvety violet. Hang luxuriously exotic candle chandeliers then accent with silky sky blue pillows.

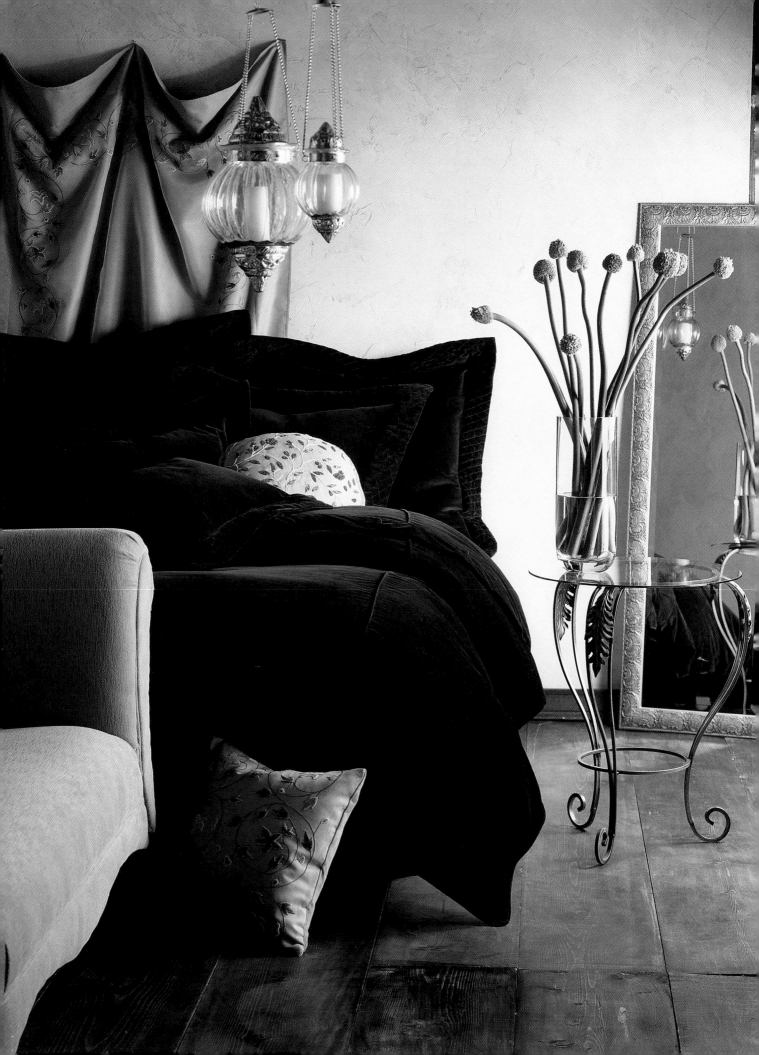

115
113
111

116
114
111

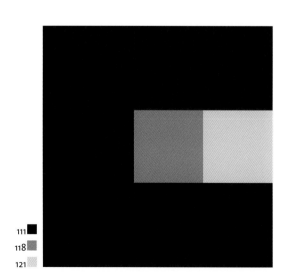

111
118
121

112
115
116

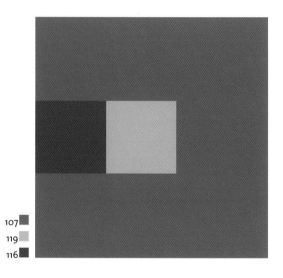

107
119
116

121
111
113

112 ■
55

115 ■
45 ■

113 ■
47 ■

118 ■
45 ■

111 ■
52

120 ▨
54

COMPLEMENTARY

112
122
1

115
124
4

116
127
7

111
123
100

113
107
95

119
128
107

■ 111
■ 34

■ 114
■ 41

■ 116
■ 37

■ 111
■ 64

■ 114
■ 56

■ 121
66

111
133

133
147

121
145

112
148

114
152

115
142

113

149

111

141

116

147

112

151

121

151

121

127

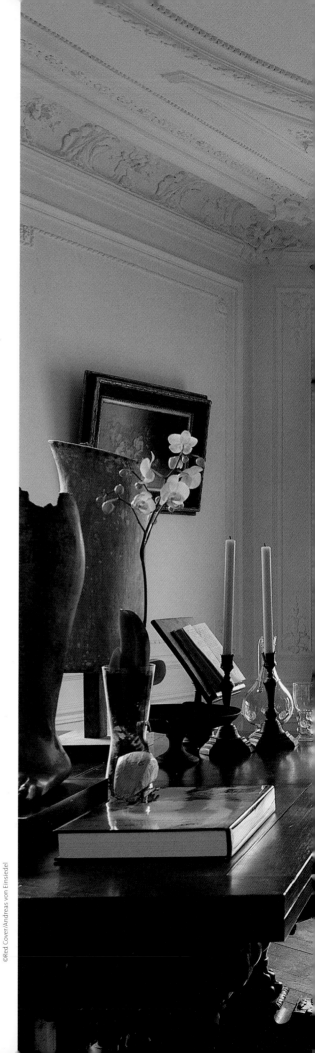

Decorating with a luxurious mix

Vibrant violets were once the exclusive domain of the wealthy and royal. Today, jewel-toned violets abound. Softly tinted, elusive violets are sometimes difficult to capture, much like the subtle shifts and changes of violet rays in natural light. From pale lilac to rich-hued mauve to saturated purples, violet is the color of luxury. Exotic and regal, a violet color scheme can also be fanciful and magical. Violets bring an ethereal mood to just about any environment. Decorate with this luxurious hue and its variations to create an atmosphere of sublime richness.

Sheer drapes in light violet add richness and dimension to this luxurious living room.

©Red Cover/Andreas von Einsiedel

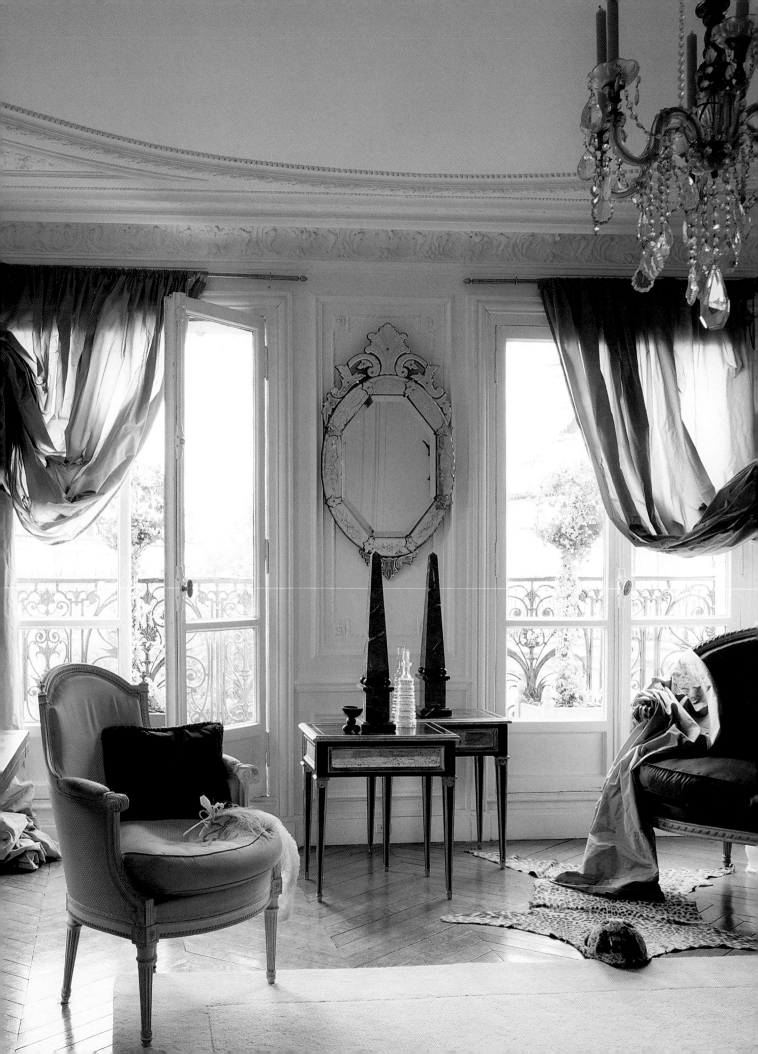

Luxurious **Tips**

•Skirted tables bring a lavish, cozy mood to a bedroom or living area. Use fabrics like textured linen, floral chintz, plush velvet, silk damask in plum and mulberry shades, or even animal print fabrics with a sateen finish—top skirted tables with an ample, half-inch-thick glass round.

•Personalize bedding and bath linens with a tone-on-tone monogram, such as violet on a periwinkle terry towel. If you do decide to monogram, invest in good quality linens, but don't feel the need to personalize everything to feel luxurious. Begin with pillowcases and guest towels, building a "monogram wardrobe" over time.

•Employ a butler's table to hold accoutrements so necessary for pampered living. Fill the lift-off tray with necessities for journal writing, such as a leather-bound journal and favorite pen.

•Today bedrooms are often the most luxurious room in a home. Carefully choose from a bevy of headboards and day beds, canopy, and traditional beds. Then dress them up with ruffled pillow shams, comforters, seasonal duvets, and throws.

•A luxurious decor is often the ultimate setting for displaying fascinating objects, such as a collection of silver tipped walking sticks nestled in an umbrella stand. Collectibles, such as antique tea caddies and small English snuff boxes, gain importance when gathered and displayed en masse. The gleam of silver is enhanced when paired with the luxurious hues of palatial violets.

•Distinctive and exotic, the ball and claw foot design of rich mahogany furnishings is particularly stylish and arresting in a luxurious home. Very dark wood finishes, which are often nearly black, accentuate and enrich a violet palette. This quintessential Chippendale motif has Eastern roots. Recall the ancient Chinese icon of the dragon's extended claw reaching for the precious pearl.

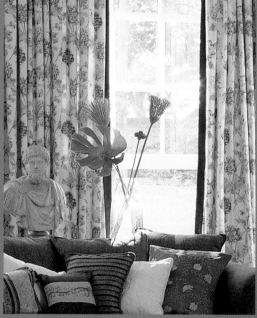

©Laura Ashley

[ABOVE]
Combine classic blue with sage greens, purply blues and creamy oatmeal hues to create a decorating mix that's not only historic but refreshingly modern.

[RIGHT]
When decorating for luxury use the soft glow of candles and well placed lamps to assure an illuminated decor that radiates richness.

© Abode UK

Romantic

Add romance to your life with old-world charm. Decorate with rosy violet for a romantic decor that's sweetly nostalgic and warm. Use old-fashioned red-violet hues—from pale opalescent shell pink to raspberry red and bejeweled amethyst. Russet browns, nutmeg, and brick shades are natural partners for red-violet hues. Combine these colors for a quaint cottage style. Anchor red-violet with earthbound neutrals like forest green, sand, and stone. Deepen a romantic palette with the addition of raisin and nearly black plum. A romantic scheme can also be wistful—blend palest hues of rose champagne with cream, milk, and biscuit. Accentuate the tender emotions of a romantic decor with touches of primrose yellow and ripe apple green.

A smaller romantic home will favor cottage style, but if your home is spacious, imagine a country manor. Decorate with traditional furnishings that feature rich lustrous woods, antiques or reproductions, and prized heirlooms. Fabrics that are timeworn and true can be used in abundance when evoking a romantic mood. Intersperse everyday fabrics, such as ticking, gingham, and paisley, with fine antique metelasse, heirloom laces, and floral chintz. Hunt for remakes of popular vintage fabrics, particularly from the eras of the 1930s, '40s and '50s. Trims of all kinds are at home in a romantic decor. Look for old-style crocheted trim, crewel work, embroidered designs, ric rac, piping, and scalloped edges to accent soft furnishings, such as bed clothes and drapes.

©Red Cover/Christopher Drake

[ABOVE]
To add instant romance to a room, decorate with the old-fashioned romantic hues of raspberry red and blush pink. Here, a bouquet of flowers on a marble table with a lusterware bowl are displayed as the perfect romantic still-life composition.

[RIGHT]
Anchor a raspberry red living room with furniture in neutral colors, favorite heirlooms, or flea market finds softened by time. Look to rich lustrous wood furnishings or wicker chairs and an old kilim rug for just such accents.

125
124
122

126
127
125

122
124
126

127
128
129

128
129
130

131
122
124

125
64

123
63

122
62

123
57

128
62

131
66

124
3
12

122
111
1

127
116
6

126
113
101

127
117
106

128
8
118

■ 125
54

■ 128
53

■ 123
45

■ 122
56

■ 126
62

■ 129
63

122 ■
147 ■

125 ■
142 ■

123 ■
148 ■

126 ■
145 ■

127 ■
149 ■

129 ■
148 ■

■ 122
■ 152

■ 124
■ 147

■ 129
■ 150

■ 132
■ 147

■ 124
■ 133

■ 126
■ 149

Decorating with a romantic mix

The key to planning a romantic decor is reaching back into your past. Combine the best of your old and new worlds for a picturesque style that will evolve as the years progress. Using a romantic palette brings a rosy, homespun glow to decorating. Comfort colors, such as berry reds and violet burgundy hues, combine effortlessly with harmonious warm, woodsy hues. Decorate with antiques as well as hand-me-downs to achieve a romantic, lived-in mood. A romantic décor is perfect atmosphere to display a nostalgic collection of antique hats, old family photos, keepsakes, and treasured mementos from yesteryear as well as today.

Here a tiny alcove is transformed into an intimate and cozy sleeping space. A skirted round table and slipper chair float in front of simply swagged window treatments.

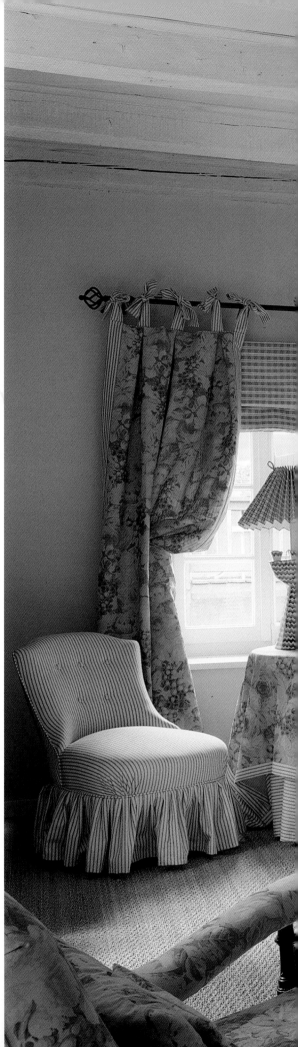

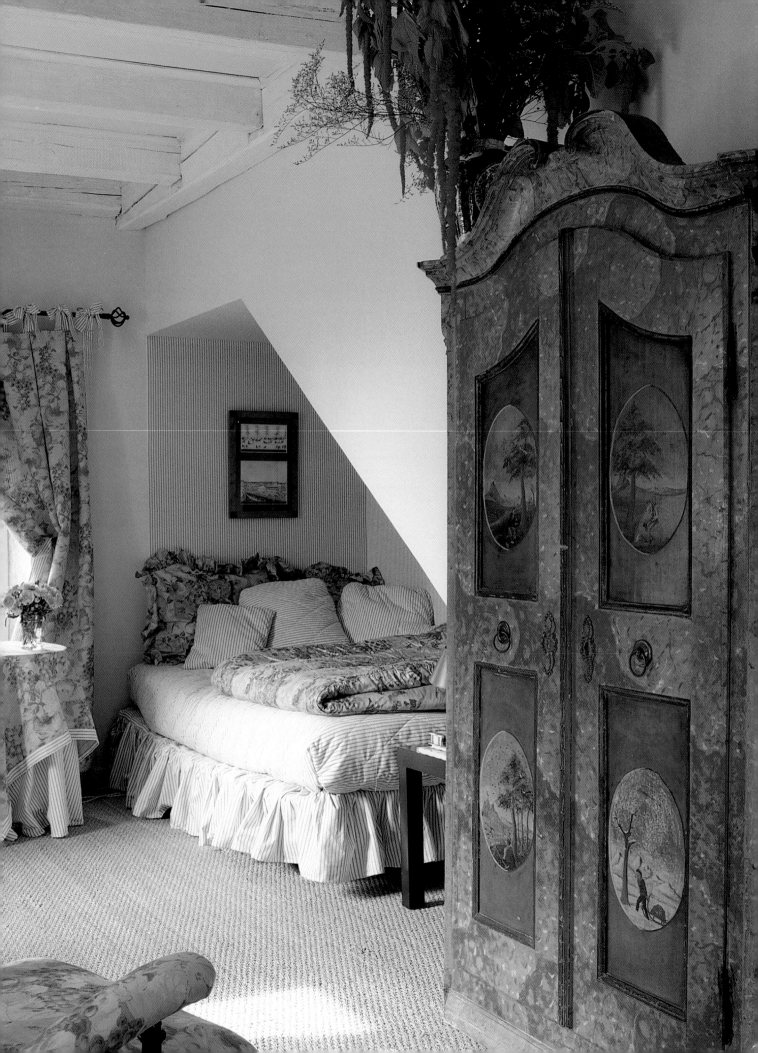

Romantic **Tips**

•Don't be afraid to use romantic furnishings that have height and breadth, such as a large armoire. Large-scale furnishings in small rooms often appear charming and quaint. Reconfigure the interior of a large armoire and use it to store fine china, crystal, and table linens in a dining room. Collect china patterns with pastoral scenes depicted in burgundy or violet, and combine with rose-tinted glassware that is finely etched for a colorful, romantic display. Or turn it into a cocktail storage area, well-stocked with bar items and liquors. Position an armoire in your entry as an added coat closet for seasonal winter scarves, coats, gloves, and mittens.

•Honor your family by making an heirloom quilt from keepsake fabrics such as rosy florals, ivory lace, and amethyst velvets. Take a cue from the crazy quilts so popular in Victorian England. Save precious baby clothes, ribbons, favorite clothing, and bits of meaningful fabrics to make your own cherished creation.

•Instantly change the mood of any candlestick chandelier by adding small colonial lampshades, widely available in a variety of colors and patterns. Choose deep purples or black with gilt trim; for cooler months, switch to tiny floral patterns on cream to greet spring.

•Bring the romance of an old hotel to your bath. Select oversized porcelain pedestal sinks and toilets, change fittings and faucets to a soft pewter or gleaming chrome finish, and install reproductions of 1920s-style light fixtures. Finally, stock with stacks of fluffy white quality towels, luxury soaps, and crisp cotton linens.

© Henry Wilson / The Interior Archive [Designer: Andrea de Montal]

[ABOVE]
These toile de Jouy pillows feature illustrations of pastoral scenes in rosy pink and rich berry hues, a fitting accent for any romantic room.

[RIGHT]
A mirrored coat-closet door creates the illusion of space in this small foyer by reflecting toile de Jouy wallpaper and drapes within this picturesque entry to a sitting room.

© Henry Wilson / The Interior Archive [Designer: Christopher Moore]